MINNESOTA
CAVES

MINNESOTA CAVES

HISTORY & LORE

GREG BRICK, PHD

Published by The History Press
Charleston, SC
www.historypress.net

Copyright © 2017 by Greg Brick, PhD
All rights reserved

First published 2017

Manufactured in the United States

ISBN 9781467135924

Library of Congress Control Number: 2017934953

Notice: The information in this book is true and complete to the best of our knowledge. It is offered without guarantee on the part of the author or The History Press. The author and The History Press disclaim all liability in connection with the use of this book.

All rights reserved. No part of this book may be reproduced or transmitted in any form whatsoever without prior written permission from the publisher except in the case of brief quotations embodied in critical articles and reviews.

Minnesota is yet in its infancy, and there is no telling what may yet be found underneath her surface.

—Luther Chamberlin, 1867

CONTENTS

Acknowledgements 11
Introduction 13

1. Prehistoric Caves **19**
 Giant Beaver Cave 20
 La Moille Cave 20
 Lee Mill Cave 22
 Lundberg Cave 23
 Reno Cave 24
 Mazeppa Cave 25
 Knapp's Cave 25
 Petrified Indian Cave 27

2. Caves of Pioneer Days **29**
 French Saltpeter Caves 29
 Carver's Cave 31
 Fountain Cave 37
 Trophonian Cave 46
 Miles Cave 47
 Jesse James Cave 50
 Quarry Hill Cave 52

3. Brewery Caves — 55
- Yoerg — 56
- Banholzer — 57
- Stahlmann's Cellars — 59
- Heinrich — 63

4. Mushroom Valley — 65
- Mushroom Gardening — 67
- Cheese Ripening — 71
- Felsenkellers — 74
- Mystic Caverns — 74
- Castle Royal — 77
- Cave Tragedies — 79

5. Minneapolis Caves — 83
- Chute's Cave — 83
- Schieks Cave — 91
- Channel Rock Cavern — 95
- Spirit Island Cave — 97

6. Southern Show Caves — 99
- Mystery Cave — 103
- Niagara Cave — 106
- Spring Valley Caverns — 109
- Catacombs of Yucatan — 113
- Hiawatha Caverns — 115
- Seven Caves — 117
- Stillwater Caves — 119

7. Northern Caves — 121
- Robinson's Ice Cave — 121
- North Shore Caves — 123

8. HEAVEN AND HELL	**125**
Unktahe's Cave	125
Newton Jenny's Cave	127
Devil's Cave	127
Tunnel of Terror	129
General References	133
Index	135
About the Author	143

ACKNOWLEDGEMENTS

Special thanks to Gordon Smith, National Cave Museum, for generous access to his vast cave postcard collection; Tony Andrea, East End Productions, for donating his photographic talents; John Ackerman, Minnesota Cave Preserve and founder of the Minnesota Caving Club; David Gerboth, longtime archivist of the Minnesota Speleological Survey; speleohistorian Gary Soule; musician Dr. Dan Senn; Dr. Kathy Stevenson, Mississippi Valley Archaeology Center; geographer Kevin Patrick, Indiana University of Pennsylvania; the ever helpful staff at the Wabasha Street Caves; Gregory Logajan, inventor of ingenious mechanical rovers for exploring caves; Red Wing caver and fossil collector Tim Stenerson, with whom I explored many of the more obscure caves of Minnesota described in this book before his untimely demise; and especially my fiancée, Cindy, who has traveled to caves around the world with me and patiently endured my crazy schedule and lack of leisure time.

INTRODUCTION

In a 2005 manifesto, "The Missing Century in the Minnesota Karst," I emphasized the hitherto unsuspected time depth and richness of Minnesota cave history. The story began with French saltpeter caves in 1700; continued with the first published description of a cave in the Midwest, Jonathan Carver's visit to Carver's Cave in 1766 and 1767; and the supposed birthplace of the state's capital city at Fountain Cave in 1838. As settlements grew, many specialized uses for artificial caves included mushroom growing, cheese ripening, beer lagering and nightclubs with outlandish features. The Nesmith Cave hoax, which reached national proportions in the years following the American Civil War, was based on a real cave, Chute's Cave, in Minneapolis. Today, Minneapolis has some of the biggest, deepest and murkiest sewer caves found anywhere, but they are little known even to residents. Mystery Cave and Niagara Cave, in the south, are the state's best known show caves to modern tourists. In the far north, the violent crashing of waves on the shores of Lake Superior has carved out caves explored by kayakers.

While Minnesota's more than three hundred caves are distributed statewide, they are clustered in two areas: the southeast, especially Fillmore County, and the Twin Cities of Minneapolis and St. Paul. These two cave clusters are related somewhat as the right and left halves of the brain: the rational, rectilinear limestone caves and the artistic, unexpected, sandstone caves, often carved by whimsy.

Introduction

Indeed, since so many caves described in this book are artificial, I would like to clarify at the onset the meaning of the term "natural cave." Among the general public, I have found that unlined, artificial caves dug into bedrock will often be called "natural caves" because the avowedly natural rock surface is plainly visible. To most geologists, and here in this book, natural refers to the space itself, not the walls. Apart from completely natural and explicitly artificial excavations, there's a third, intermediate category of cave. This is the anthropogenic, or artificially induced, cave. It's where human activities have unintentionally created caves, as by leakage from sewers, which scour out voids.

The pioneering geologist Newton Horace Winchell (1839–1914), who wrote so widely on Minnesota geology, rarely mentioned caves, and he did not use that word in his report on cave-rich Fillmore County. It was not until 1944 that "a karst type of topography" is described for Minnesota. Characteristic of the southeastern counties, karst landscapes are notable for sinkholes, caves and springs. Rainwater, made mildly acidic by its passage through soil, enters the sinkholes, flows through the caves—dissolving them out—and discharges at springs. Few lakes are present because of the underground drainage. Known popularly as the Driftless Area because it was supposedly avoided by the glaciers—lacking glacial deposits, or drift—portions of it were indeed glaciated according to later research.

Here's some basic layer-cake geology that will aid in understanding the context of the caves to be described in this book. We start from the topmost bedrock layer and take a journey toward the center of the earth. Most of the caves described in this book belong to one of four geological layers: Galena limestone, St. Peter Sandstone, Oneota dolomite, and the Jordan Sandstone. While the rocks themselves are old, the caves found in them are much younger, usually no older than the carving of the river gorge to which they presently drain.

All the really big natural caves, like Mystery and Niagara, along with several hundred smaller ones, are found in the Galena limestone layer. This rock formation was named for exposures in Galena, Illinois; there, and in the adjacent states, it contains galena (lead sulfide) veins. Its two prominent layers are the upper Dubuque limestone, forming low, wide, squarish passages in cross-section, and the lower Stewartville dolomite, forming tall, narrow passages. The bedrock was laid down in shallow seas during Ordovician times (485 to 444 million years ago).

The next cave-related layer below that one is the St. Peter Sandstone, the greatest layer in terms of utility spaces owing to its ease of excavation. St.

INTRODUCTION

Paul was known to the Dakota Indians as "White Rocks" because of this glaringly white layer, exposed in its river bluffs, and geologist David Dale Owen (1807–1860) officially named this rock in 1852 for outcrops near Fort Snelling, along the St. Peter's River—now the Minnesota River. The St. Peter layer has an average thickness of about 100 feet regionally. However, it's about 150 feet thick at its type section at Fort Snelling, and it ranges up to 500 feet thick at Joliet, Illinois, as determined from drilling records. That leaves plenty of three-dimensional volume for caves and tunnels.

The St. Peter Sandstone is very extensive for a single formation, underlying a quarter of a million square miles in the Midwest. The St. Peter is a "sheet sand," meaning that it was laid down flat, like a sheet, over large areas, by a warm, shallow sea that invaded the continent from the south. It was the last major sandstone layer to be deposited in the Upper Mississippi Valley. In unlined sewer tunnels you can sometimes see cross-bedding in the walls, representing the old sand dunes of the shoreline beaches

The St. Peter has an almost saintly purity throughout most of this range, suggesting that it has been recycled from older sandstones, geologically winnowed of its impurities, leaving it, as the textbooks say, 99.44 percent pure silica. The St. Peter was often called the "Ivory Soap of sediments" because that brand of soap was, coincidentally, advertised as "99.44% pure." In glass recipes, even small amounts of contaminants are injurious, so this degree of purity was considered crucial. Locally, the sand was used for making windshield glass, as at the former Ford Motor Company plant in St. Paul, with its two and a half miles of tunnels. Other uses were for foundry sand and mortar sand.

Most importantly, the St. Peter Sandstone, in the Minnesota part of its range, lacks natural cementation, hence the individual sand grains are easily excavated by natural and artificial means. Natural caves form in the St. Peter by a process known as "piping," a form of erosion caused by flowing groundwater. The term *piping* was derived from the pipe-shaped voids created by water flowing underground. Piping forms two different kinds of caves in the St. Peter: tubular caves, best exemplified by Fountain Cave in St. Paul, and maze caves, best seen in Schieks Cave under downtown Minneapolis. One particular layer within the St. Peter, called the "Cave Unit" by Professor Robert Sloan, is more susceptible to piping and thus more favorable to cave formation than the others.

We continue our imaginary journey downward through the geological layers with the Oneota dolomite layer, which is a dolomite, or magnesium-rich limestone, named after the Oneota River in Iowa. This layer runs

too deep under the Twin Cities to be useful for utilities. Instead, it serves, hydrologically coupled with the underlying Jordan Sandstone, as Minnesota's most prolific aquifer, supplying up to three thousand gallons per minute to water wells drilled into it. The high discharge is partly due to the fact that this layer has large water-filled voids, which, if they were drained and entered by human beings, would be considered caves.

At Hastings, the Oneota dolomite layer is warped upward sufficiently to be exposed at the surface, its otherwise water-filled maze caves thus available for human exploration. Caves such as Lee Mill Cave, overlooking scenic Spring Lake, and Miles Cave, below the falls of the Vermillion River, are examples. Most of the best caves in Wabasha, Winona and Houston Counties of Minnesota, and some of adjoining Wisconsin's best-known caves, are found in this layer.

We go farther down through the layers. The Cambrian Period (540 to 485 million years ago) is below the Ordovician. Many of the caves containing prehistoric artifacts are found in the Jordan Sandstone layer of this age, named after Jordan, Minnesota, which bears many similarities to the St. Peter Sandstone.

Nearly nine-tenths of all earth's history, however, falls under the domain of Precambrian time—the time when the earth's crust was formed and life originated. The shoreline caves of Lake Superior are eroded into rocks of this age, 1.1 billion years old.

With this perhaps too brief introduction, we are ready to tackle the mysteries of the caves. This book does not purport to provide a description of all Minnesota caves, of which there are more than three hundred. Indeed, several more volumes would be required to complete the picture. I had to be very selective, choosing caves that have a lengthy history prior to the advent of cave exploring clubs over those that did not and preferring caves that I had personally visited. Some large and beautiful caves have been omitted because they do not have any history beyond a mere listing of the events surrounding their recent discovery and mapping by cavers. And while many of the artificial caves began as mined-out spaces, mines themselves, such as for iron or silica, are not included in this book, unless they were later repurposed. I also emphasize hybrid and imaginary caves such as they occur in Minnesota cave history, because these give us some insight into the workings of the human mind as it deals with caves.

I have made an attempt to group the caves as naturally as possible, despite the diversity among them. Some caves could easily fit in several different categories. Chapter 1, "Prehistoric Caves," includes those of archaeological

significance. Chapter 2, "Caves of Pioneer Days," deals with caves that played a role in the early history of our state, most notably Carver's and Fountain, on the Mississippi River, which have been visited by so many travelers over the years. Chapter 3, "Brewery Caves," is grouped by an industry established by German brewers, who immigrated to Minnesota in the second half of the nineteenth century, concentrating in St. Paul. Chapter 4, "Mushroom Valley," has a geographic focus in Mushroom Valley—a stretch of the Mississippi valley in St. Paul—for the century from the 1880s to the 1980s. It was known for silica mining and mushroom growing. Chapter 5, "Minneapolis Caves," tackles the three great natural caves of that city. Chapter 6, "Southern Show Caves," describes the belt of show caves running across southern Minnesota, almost like a money belt of sorts, with Fillmore County forming the square buckle. Chapter 7 deals with a small group of northern caves. Chapter 8, "Heaven and Hell," presents an odd assortment of caves touching on larger themes. Finally, a section of general references lists some cave classics and earlier publications about Minnesota caves.

1
PREHISTORIC CAVES

Native Americans have inhabited the Upper Mississippi valley for twelve thousand years. In North America, archaeological time is divided into a three age system: Paleo-Indian, Archaic and Woodland. Paleo-Indians were the big game hunters who appeared at the end of the last ice age, and there are relics of them in Minnesota. Indians of the Woodland period, by contrast, hunted smaller game, developed agriculture and pottery and frequently buried their dead in earthen mounds. Archaic is the much lengthier interval between these two. Most of the artifacts found in caves and rockshelters in Minnesota belong to the Woodland period. Rockshelters are merely shallow caves without a dark zone.

Many Native American carvings on rock outcrops were recorded by the Hill and Lewis archaeological survey of 1881 to 1895. Alfred Hill provided the financial backing, while Theodore Lewis conducted the fieldwork, most importantly his 1888 rock art ramble, hiking along the Mississippi River from Carver's Cave in St. Paul to Allamakee County in northeastern Iowa, recording the drawings from the river bluffs and seven caves. Many of Lewis's drawings were reprinted in Winchell's *Aborigines of Minnesota* (1911). The petroglyphs include abstract geometric forms and representational imagery such as rattlesnakes and thunderbirds. If the images were painted, instead of carved, they are called pictographs.

Giant Beaver Cave

The Giant Beaver Cave of the Highland Park neighborhood of St. Paul would have easily ranked as the oldest and most interesting archaeological and bone cave in Minnesota if its earlier prospects had panned out. But it wasn't really a cave, and it wasn't a true beaver that lived there. Nor did Ice Age man live there, as some alleged.

On July 15, 1938, Works Progress Administration (WPA) laborers encountered the site while constructing a road into Hidden Falls Park. Dr. Louis Powell, curator at the St. Paul Institute, correctly identified the bones as those of the extinct giant beaver. This beaver occupied a wide swath of North America after the last ice age and was about the size of a black bear, its generous dimensions in line with the other megafauna of the day. But some of its habits were not those of the living species of beaver we are familiar with. And that news was eclipsed when Clinton Stauffer, a geology professor at the University of Minnesota, announced that a "sharp bone splinter" found at the site could be a relic of man from 20,000 years ago.

But that was before radiocarbon dating was developed as a way of telling how old something was. Bruce Erickson, a paleontologist from the Science Museum of Minnesota, restudied the skeleton and in 1967 reported an age of 10,320 years for it. The so-called cave was really only the Platteville Limestone waterfall ledge of Hidden Falls, which apparently had collapsed over the beaver, trapping and preserving its remains, which are now mounted at the museum. And while there is no direct association with the Paleo-Indians—the tenuous splinter notwithstanding—the beaver lived at a time when they are known to have been in the region. Overall, it was certainly the most interesting story for the cave curious in the Highland Park neighborhood—where I grew up.

La Moille Cave

In 1888, Theodore Lewis, famous for having recorded many Minnesota antiquities, sketched the petroglyphs on the walls of La Moille Cave, named after the nearby town of La Moille, south of Winona, Minnesota. In an 1889 entry for *Appleton's Annual Cyclopaedia*, Lewis wrote, "There are more pictographs in this cave than have been found at any other point in the Mississippi valley," making it the Sistine Chapel of Minnesota rock art. These

HISTORY & LORE

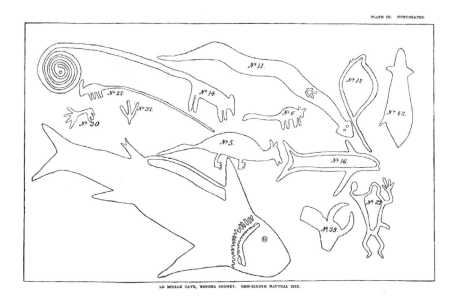

Petroglyphs recorded at La Moille Cave by Theodore Lewis during his "rock art ramble" down the Mississippi in 1888. *Winchell, 1911*.

included fishes, rattlesnakes, thunderbirds, raccoons, human figures and so forth. In particular, the fishes were rendered in exquisite detail by some prehistoric ichthyologist. This material was incorporated into Winchell's *Aborigines of Minnesota* (1911) and has been reproduced for an exhibit at the Winona County Historical Society Museum.

La Moille Cave is now nearly filled with sediment, leaving a few feet of clearance, just enough to crawl around. The filling is presumably due to the deposits of Trout Creek, resulting from construction of the nearby Lock & Dam No. 6 in the 1930s, which raised the river level and dammed back its tributaries. Owing to the softness of the Jordan Sandstone, it's difficult to identify the petroglyphs, which became effaced over the years. A spring at the rear of the cave guarantees a mud bath to any visitor.

By contrast, La Moille Rockshelter was subsequently discovered one quarter mile to the southeast of La Moille Cave during work on U.S. Highway 61. The rockshelter became famous for containing some of the earliest pottery known in Minnesota. The La Moille deposits, fifteen feet thick, span the transition from the Archaic to the Woodland period. The rockshelter was a Native American fishing camp dating to about 1500 BC. Sadly, after being discovered by road workers, the site was destroyed by the

same. And couldn't you just foresee that two sites with such similar names, so close together, would be confounded by later archaeologists? Indeed, they were. The production of hybrid caves seems to be a minor industry in Minnesota, as we shall see.

LEE MILL CAVE

Lee Mill Cave, with its magnificent view of Spring Lake, formed in the Oneota dolomite of Schaar's Bluff, near Hastings, Minnesota. Excavated by the Science Museum of Minnesota in the early 1950s, archaeologists found human bones crushed beneath a boulder, pottery and large numbers of fish bones. The cave today is littered with raccoon bones and scat. It has a natural chimney that conducts smoke upward through a crevice in the rock, which perhaps was another reason why early peoples favored it. Past a constriction in the cave passage, there's another, smaller room, a sort of inner sanctum, warm in winter and cool in summer. Any visitor with a tinge of arachnophobia will find this small back room, which is crawling with large spiders, a bit disturbing. The gristmill that gave the cave its name was owned by the Lee family.

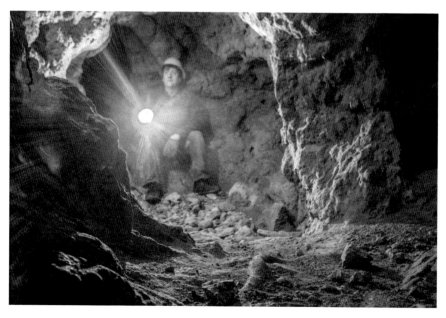

Lee Mill Cave, where human bones were found in the 1950s. *Tony Andrea, 2016.*

Near Lee Mill Cave is Korneski Cave, strung with lights, which had narrow-gauge tracks used for excavating the sediments, as if someone had been preparing the cave for tours. But sometimes the physical evidence for commercialization is insufficient by itself to establish intent, and we require other forms of documentation to prove a former show cave.

Lundberg Cave

When they weren't out on Lake Pepin, summer tourists at the cozy fishing resort of Camp Lacupolis ("The Home of the Walleye") would amuse themselves by finding Native American artifacts. But in 1926, amateur archaeologists began excavating a cave in the Oneota dolomite outcrops above the resort. They found skeletal remains of bears and humans, pottery embellished with "hieroglyphics" and a hearth with abundant ashes. They wisely contacted Albert Jenks, head of anthropology at the University of Minnesota, who visited the cave in 1927. Jenks completed the excavation and prepared a map of the cave. G. Hubert Smith revisited the cave in 1931 as part of his southeastern Minnesota rockshelter survey, followed by Lloyd Wilford in 1950. Wilford noted that this burial cave had been grossly disturbed in recent years by pothunters.

Lundberg Cave, on private land, is roughly uterus shaped in plan, completing the tomb-womb metaphor that has become a commonplace in cave literature. Based on my visit in 2005, the main walking passage, thirty feet long and eight feet high, connects with the two crawling passages, each thirty feet long and three feet high. Jenks's notes imply that the cave is a littoral (shoreline) cave, formed by the "lapping of waters" when Lake Pepin was much higher, but the features don't bear this out. The cave does not have the morphology of a typical littoral cave. The cave was dissolved out along a joint that can be seen running up the bluff. The mud fill, in which the skeletons were found, and which remains intact along the walls even after the extensive archaeological digs, appears to have entered the cave from the surface through vertical joints, where the bluff is pulling away. Although true littoral caves exist at Lake Pepin, they are much smaller and at a lower elevation, closer to the present-day lake level. Lake Superior is where we find Minnesota's best examples of littoral caves (see North Shore Caves, on page 123).

Reno Cave

Reno Cave is located in an outcrop of Jordan Sandstone, high on a ridge near the town of Reno, overlooking the three states of Minnesota, Iowa and Wisconsin. While the cave is on public land, it's a long roundabout hike to reach it, and the site is not marked. The cave's walls are vertically fluted where rainwater has seeped in through the Oneota dolomite caprock over thousands of years, widening the rock joints and washing out the void space underneath. But the cave, though small, is well known for the prehistoric petroglyphs carved in the walls, especially the famous Reno face, first documented by peripatetic antiquarian Theodore Lewis in 1888. Subsequent surveys found them effaced by modern graffiti.

Natural bays with seats and windows, present where the elements have gnawed through the walls, allow one to gaze off into the distance. Perhaps someone was sitting in that same natural chair just after the Ice Age, looking out as a modern visitor would. What landscape changes would our hypothetical observer have seen over the millennia from this privileged perch? We picture in our minds the surging to and fro of grassland and woodland after the retreat of tundra to the far north.

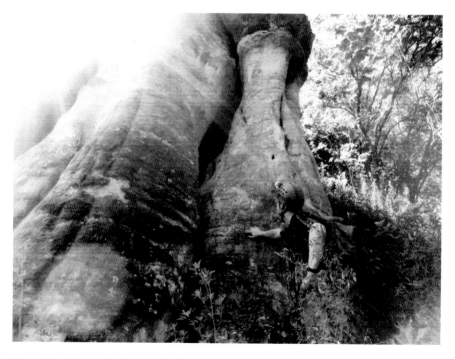

Reno Cave, famous for its petroglyphs, especially the Reno face. *Tim Stenerson, 2015.*

Mazeppa Cave

Native Americans said there was a spirit lurking in this colorful natural cave in the Jordan Sandstone on the outskirts of the small town of Mazeppa, south of the Twin Cities. Settlers took this to mean a devil. For many years, Mazeppa Cave, seventy feet long, has been used as a root cellar, sealed behind a door by the landowner, but it was investigated by a team of archaeologists in 1997. Its walls are vertically grooved by many petroglyphs. A narrow tunnel at the back end of the cave could be a symbolic entry point into the earth, where a shaman could go to consult with the "rock people" about which mineral remedy could be used to treat his patients. More so than any other petroglyph cave in Minnesota, this one would appear associated with shamanistic practice, perhaps our equivalent of Samuel's Cave in Wisconsin.

Knapp's Cave

A large, gaping cave entrance in the reddish Cambrian sandstones has attracted generations of canoeists on the St. Croix River to stop and investigate. What they may not realize is that an article by geologist R.W. Strong appeared touting this mammoth cave of the St. Croix back in 1900, and despite the hyperbole of the comparison, it is recognizable today. Knapp's Cave remains the largest natural cave in the St. Croix River valley and the only one with significant archaeological remains. The namesake Captain Knapp was a steamboat captain out of Osceola, Wisconsin, just across the river.

> *OSCEOLA, Wis., Special, Nov. 10.—A mammoth cave has been discovered, or rediscovered, in a large rock bluff on the Minnesota side of the St. Croix river, two miles southwest of Osceola. Its entrance is half way up on a solid rock bluff 200 feet high and is large enough to admit a man walking erect.*
>
> *It has long been known that a small cave existed there, from the fact that that was the place where the Sioux and Chippewas made their peace treaties, and also from the fact that Indians often met there in mortal combat, spilling their life's blood on the moss-covered rocks, but it was not supposed to be of such mammoth proportions until recently.*

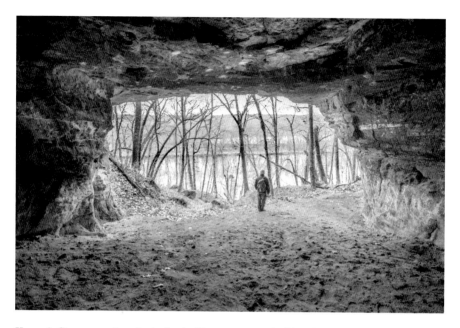

Knapp's Cave, an archaeologically significant cave overlooking the scenic Cedar Bend country of the St. Croix River valley. *Tony Andrea, 2016.*

An investigation regarding the value and construction of this cave was made this week by Fred Lindberg and William Messenger, two Osceola citizens, and the representative of the Pioneer Press, *and they discovered some wonderful features.*

The first apartment of the big cave is some thirty to forty feet wide by ten to twenty feet high and 100 feet long. Leading from it is a round passageway about two feet in diameter and twenty feet long, which leads to another room of the same dimensions. Then from this another passage way leads to a third room. In this manner dungeon after dungeon is passed, but it is now impossible to go into it more than 500 feet, owing to the foul air which predominates.

Partitioned from the large room are several smaller apartments, hewn from solid rock—there may be a hundred of them, it is impossible to state—which proves beyond a doubt that, while the cave proper may be the work of nature, these rooms are the result of labor by human hands—perhaps a thousand years ago.

The first one of these small rooms is reached soon after entering the main cave, by a stairway leading upward to a point at least twenty feet high, at the top of which is a small round entrance, eight feet long and just wide

enough to allow a man to crawl through, but when once past this one enters a room at least twelve feet square and six feet high, hewn from solid rock. This room, like the others, has only one outlet, but is perfectly dry, and is large enough to accommodate two persons for all ordinary purposes.

An attempt was made to find the remains of or utensils employed by the builders of this wonderful cave, but nothing of importance was discovered, except utensils bearing dates as early as 1840, and Indian signs.

Some of the old residents here claim that thieves made this cave their home forty or fifty years ago, and it is possible that treasures are hidden there to-day. It is well known that one thief stole sixteen head of cattle and kept them there for several weeks about thirty years ago. A small, winding path from above the bluff was no doubt employed to drive the animals into the cave. The animals were recovered, but the thief hid in some unknown recess and escaped.

Many persons now believe that this cave will equal in magnitude the wonderful Mammoth Cave of Kentucky, or the Black Hills caves of South Dakota, and they have good reason for believing this, for nearly a mile back of the front entrance to the cave is a large recess in the earth, into which a stream disappears, and it is thought to be an entrance to the cave. Further investigation will be made.

The archaeologist Lloyd Wilford excavated Knapp's Cave in 1951 and found it to be a temporary campsite of the Woodland period. He called it "Leslie Cave" after the contemporary landowner, but it is marked as Knapp's Cave on U.S. Geological Survey (USGS) quadrangles. It was later explored by members of a local caving club, the Swedish Underground (this area having been settled by Swedish immigrants). Being floored with thick, dry reddish sand, it was an ideal party cave, and local residents have had to restrict access to the waterfront from the landward side.

PETRIFIED INDIAN CAVE

Petrified Indian Cave, or merely Indian Cave, crams into its short, tight passages the kinds of archaeological and historical associations that the promoters of Mystery Cave, its far larger neighbor, probably would have liked to have had. As such, this prehistoric cave forms a perfect segue into our next chapter on the caves of pioneer days.

Overlooking the South Branch of the Root River, in Fillmore County—certainly the most cave-riddled river in Minnesota—the large, frost-shattered mouth of the cave narrows down abruptly to a tight corridor running back into the Galena limestone bluff for 240 feet. It received its name from the story told by settler George Bacon of how he went far into the cave as a youth in 1885 and saw a petrified Indian woman standing against the wall.

Upon exploring the cave in 1969, however, modern cavers, squeezing sideways, came across a flowstone deposit on the wall in the suspected location of the supposed Indian. They concluded that what Bacon had seen was a stalagmitic column fused up against the wall.

The validity of the petrified Indian story notwithstanding, the cave does contain genuine artifacts. In 1970, archaeologist Jerry Oothoudt found a hearth while excavating the entrance, but the dark zone of the cave does not appear to have been used. As early as the 1920s, archaeologist Albert Jenks had recognized that the unglaciated southeastern corner of Minnesota, with its caves and rockshelters, had archaeological potential, like the Les Eyzies region of France, where so many art and bone caves had been discovered, and Oothoudt's work built on this insight.

2
CAVES OF PIONEER DAYS

The earliest European visitors to what is now Minnesota were Frenchmen in the mid-seventeenth century. After the French and Indian War (1754–1763), the land was acquired by Britain in 1763 and ceded to the United States after 1783, although the British retained a strong presence until after the War of 1812. Explorers and pioneers from all three nations documented caves along the way.

French Saltpeter Caves

The extended French presence in the Upper Mississippi valley required gunpowder, and the usual assumption (valid in most cases) is that it was imported. A vital constituent of gunpowder is saltpeter (potassium nitrate), a mineral sometimes obtained from caves. The French fur trader Pierre-Charles Le Sueur (1657–1704), while ascending the Mississippi River in 1700, reported saltpeter caves in his journal, which researchers have reasonably interpreted as being located along the west side of Lake Pepin, in Minnesota. This is the earliest reference to caves in what is now Minnesota. Le Sueur's journal remained unpublished for many years, but according to a recent translation, under the dates September 10 through September 14, 1700, we read:

> *In these regions, a league and a half to the northwest, there is a lake named Pepin, which is six leagues long and more than a league wide. It is bordered on the west by a chain of mountains; on the other side, to the east, there is a prairie, and to the northwest of the lake a second prairie two leagues long and wide. Nearby there is a chain of mountains which must be two hundred feet high and more than a half league in length. Many caves are found there in which bears hibernate in winter. Most of these caverns are more than forty feet deep and between three and four feet high. A few have very narrow entrances, and all of them contain saltpeter. It is dangerous to enter them in summer because they are filled with rattlesnakes, whose bite is very dangerous. M. Le Sueur saw some of these snakes that were six feet long, although usually they are only about four feet.*

Le Sueur's comments about the caves being inhabited by bears in winter and rattlesnakes in summer suggest that they were visited (by someone) throughout the year, and presumably, there would have been a good reason for this. Although Le Sueur described the Lake Pepin caves as containing "saltpeter," he was more likely referring to a precursor substance (calcium nitrate), not potassium nitrate. The prevailing humidity in Minnesota caves is too high for him to have encountered anything other than deliquescent salts (dissolved in the sediment) rather than the crystallized saltpeter seen in desert regions. Apart from whitish snow-like efflorescences, not even experienced saltpeter prospectors could identify nitrate-rich sediments by sight and the usual confirmation was a bitter taste and other subtle clues until modern chemical tests for nitrates were developed. But this precursor could be easily converted to saltpeter.

The location of Le Sueur's saltpeter caves, near Red Wing, Minnesota, as inferred from his journal, was examined more than three hundred years later, in 2004. They are low, narrow crevices in the Oneota dolomite, where the bluff is peeling away. Sediment samples collected there and from other rock crevices in the Lake Pepin bluffs revealed a high nitrate content (up to 3.5 percent) in the laboratory. This compares favorably with the nitrate content of sediments from known American saltpeter caves in Kentucky, which range between 0.01 percent and 4.0 percent nitrate. Even though no mining tools or indications of saltpeter mining were observed in any of the Minnesota caves, the abundant nitrate (likely of organic origin) in cave sediments at the approximate location described by Le Sueur corroborates that there was a kernel of truth to what he reported in his journal. That, in one nutshell paragraph, sums up the years of toil I devoted to my doctoral research!

Cave saltpeter would go on to play an important role in American wars, from the Revolutionary War and War of 1812 to the Civil War, where it became a strategic mineral for the Confederate armies, cut off as they were by a naval blockade. As late as World War I, natural nitrate deposits were avidly sought out, but they were finally rendered irrelevant by the discovery of atmospheric nitrogen fixation, the so-called Haber-Bosch process.

Carver's Cave

Many natural features are considered *wakan*, or sacred, by the Dakota Indians, and they refer to Carver's Cave as *Wakan Tipi*, the Dwelling of the Great Spirit. Jonathan Carver (1710–1780) visited what he called the "Great Cave" in 1766 and again in 1767, and it became the earliest Minnesota cave in the published literature when the first edition of Carver's bestselling *Travels Through the Interior Parts of North America* appeared in 1778. Others, decades later, renamed it Carver's Cave, the name used here because I have found in my correspondence that it is more recognizable to historians outside our immediate vicinity.

Carver's Cave is the baptismal font of Minnesota caving. On November 14, 1766, Carver reported his exploration:

> *About thirty miles below the Falls of St. Anthony, at which I arrived the tenth day after I left Lake Pepin, is a remarkable cave of an amazing depth. The Indians term it* Wakon-teebe, *that is, the* Dwelling of the Great Spirit. *The entrance into it is about ten feet wide, the height of it five feet. The arch within is near fifteen feet high and about thirty feet broad. The bottom of it consists of fine clear sand. About twenty feet from the entrance begins a lake, the water of which is transparent, and extends to an unsearchable distance; for the darkness of the cave prevents all attempts to acquire a knowledge of it. I threw a small pebble towards the interior parts of it with my utmost strength: I could hear that it fell into the water, and notwithstanding it was of so small a size, it caused an astonishing and horrible noise that reverberated through all those gloomy regions. I found in this cave many Indian hieroglyphicks [sic], which appeared very ancient, for time had nearly covered them with moss, so that it was with difficulty I could trace them. They were cut in a rude manner upon the inside of the walls, which were composed of a stone so extremely soft that it might*

> be easily penetrated with a knife: a stone everywhere to be found near the Mississippi.

Carver's liminal auditory and visual experiences, as recorded in his journal, the fact that the cave was located below a Native American burial ground, marked with petroglyphs, and was the source of a spring of pure water, is more than enough for this cave to hold a special significance for anyone.

Carver carved the arms of the king of England among the petroglyphs in the cave. He thereafter visited St. Anthony Falls and ascended the Minnesota River, spending the winter with the Dakota Indians in a bark house. The following spring, he returned to the cave and on May 1, 1767, while attending "a grand council," Carver was made an honorary chief, supposedly receiving from the Indians a grant of ten thousand square miles, stretching from Minneapolis to Eau Claire, Wisconsin. I say *supposedly* because Carver never made the claim himself—it surfaced after his death. The grant story took many years to play out, promoted among others by the bizarre Reverend Samuel Peters, who wanted to establish a colony known as "Petersylvania" with a capital near present-day Fountain, Wisconsin. But U.S. Chief Justice Marshall disposed of the claim in an 1823 decision.

One of the unusual creatures described in Carver's manuscript was the buffalo snake. The tale grew more bizarre with each retelling. The following version of this warped story appeared in the *Pittsburgh Gazette* on May 19, 1818:

> *Returning from the Indian hunting ground situated near the mouth of the St. Peter's, I had occasion to go ashore at a rock which forms the cave, mentioned by Carver. Our attention was attracted by a noise, resembling the bellowing of a Buffaloe* [sic]*; we immediately proceeded in search of the object, and at the mouth of the cave, encountered a serpent of prodigious appearance, probably fifteen feet long, and proportionately thick, with four short legs, resembling the alligator; his head was disproportionately large, with glossy eyes, situated towards the back of the head; the back was of a shining black, covered with strong, and apparently impenetrable scales; the belly variegated with different colours; its tail, on perceiving it, was coiled on its back, except when it beat the ground, which was also accompanied by bellowing. The whole party stood with muskets cocked, transfixed with terror, until it quietly glided into the cave.*

With the founding of St. Paul in 1841, Carver's Cave received increased visitation. James Goodhue, editor of the *St. Paul Pioneer Press*, explored the cave in 1851 but was rather dismissive: "Carver's cave looks about like the roof of a man's mouth seen through a magnifying glass." Daniel Curtiss, in his *Western Portraiture and Emigrants Guide* (1852), reported that "Carver's Cave is one of some note; but it can rarely ever be explored, as the entrance to it is constantly changing and being obstructed by sliding rocks and earth, which frequently fill up the orifice, so that there is no access for several days, till the little stream issuing from it bursts out again, leaving a passage, sometimes, through which a man can enter and explore, though it is a hazardous experiment, not often attempted."

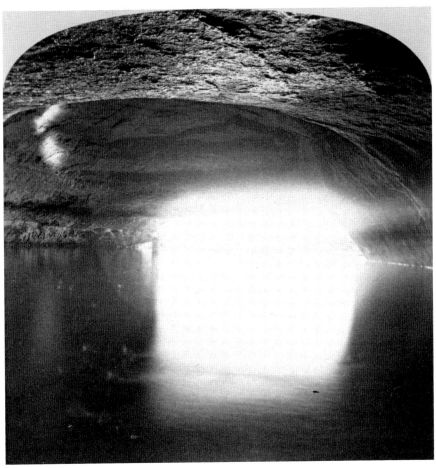

Carver's Cave, looking out the entrance over the subterranean lake, by Illingworth, circa 1875. *Trustees of the Boston Public Library.*

In 1867, the Minnesota Historical Society held a "Carver Centenary" at the cave, and local druggist Robert O. Sweeny drew the first ever depictions of the cave from several perspectives. The famed rattlesnake petroglyphs were admired by torchlight while the guests rode a boat across the subterranean lake. Other petroglyphs, sketched by the antiquarian Theodore Lewis in 1878, represented men, birds, fishes, turtles, lizards and so forth. Many of them were destroyed when the cliff was shaved back to accommodate the railroad switchyards in front of the cave. In 1886, Thomas Newson, in his *Pen Pictures of St. Paul*, wrote, "The entrance to the cave is at present blocked by a railroad track. Its capacious chamber is filled with beer barrels. Its pearly stream has ceased to flow. It is slowly dying of civilization."

In recent years, Carver's Cave has been reinterpreted as a sort of prehistoric planetarium, with the petroglyphs representing Dakota constellations. After all, there was a natural dome-shaped ceiling in the front room of the cave before that part was destroyed by railroad construction. Perhaps it represented the dome of the heavens? In this scenario, the rattlesnake petroglyphs in the ceiling are seen as bands of stars. While an attractive notion, comparison with known Native American planetarium caves elsewhere does not support this interpretation. In the known examples, stars are represented as small crosses inside the outline of the petroglyph, whereas the Carver's Cave snakes are empty outlines or contain the snake's chevron pattern. No stars are represented among the petroglyphs at Carver's Cave.

Garrick Mallery's authoritative classic, *Pictographs of the North American Indians* (1886), supplies a more plausible explanation that can be applied to most of the petroglyphs seen at Minnesota caves, namely, that they are clan or personal totems with which Native Americans registered their visits to the caves. Mallery documented how the Dakota Indians themselves did this at the famous Pipestone Quarry in western Minnesota, into historical times. Archaeoastronomy need not be invoked to explain these petroglyphs.

The most dramatic reopening of Carver's Cave occurred in 1913. John H. Colwell, president of the Mounds Park Improvement Association, was appointed to its exploration committee and promptly set out to relocate the cave. To learn its whereabouts, Colwell first "talked with A.L. Larpenteur, St. Paul's oldest pioneer, about the cave." John W. Armstrong, Ramsey County surveyor, then showed Colwell where to dig to reopen the cave, which had been "lost thirty years" owing to the accumulation of talus at the foot of the bluff. Shortly after, Boy Scouts were set to begin digging open the sealed cave—a role they have reprised up to the present day at other Minnesota caves.

On November 5, 1913, Colwell reopened Carver's Cave to the rays of the setting sun. Colwell's goal was to commercialize the cave, stringing lights and building a flight of stairs down the bluffs from Short Street. A gaudy electric sign on the bluffs would be visible from the downtown area, attracting even more visitors.

But first, Colwell had to drain the twelve-foot-deep lake inside Carver's Cave and explore it to the very end. This would not be an easy task, as others have found. While the lake water drained away, more was pouring into the rear of the cave through hidden conduits. It was difficult to find a spot low enough to drain the lake without deluging the nearby railroad tracks.

Strange visitors from the dark, mysterious interior of the cave began to show themselves as the work progressed. On November 13, a newspaper reported, "Blind crayfish have been found in Carver's Cave. Several have floated from the subterranean lake or beyond from the unexplored chambers that lie past the narrow opening of the first cavern."

On December 15, Frank Koalaska, Colwell's erstwhile foreman—but now a rival—claimed to have found the "4th Carver's Cave." "The innermost chamber is 50 feet high at one place," a newspaper reported. "The roots of trees growing on the bluff penetrate the walls, and there is a 20-foot fall of pure water in it. A piece of clay pottery bearing Indian hieroglyphic inscriptions was found underneath the sand on the floor of the cavern." The room was dubbed "the most beautiful of any so far discovered." After this outrageous claim, the foes became even more embittered, with Colwell supposedly setting off loud blasts of stolen dynamite in the cave, upon which a nearby landowner threatened "to fill the cave up" unless he desisted. Journalists, producing reams of column, began characterizing the dispute in mock-heroic martial terms, until a "truce" was declared on January 7, 1914.

Perhaps because of this bitter feud, Colwell's original plans never came to fruition. A decade later, Colwell authored a series of eight articles, "The Story of Dayton's Bluff," which appeared in the *Minneapolis Tribune* in late 1924. His articles, sandwiched between glowing advertisements for "Lydia E. Pinkham's Vegetable Compound," make no mention of further plans to commercialize the cave. "Carver's Cave," he concluded somewhat mysteriously, given all the media hoopla, "has never been officially explored."

A journalist, Charles T. Burnley, drafted a conjectural map of the alleged discoveries in 1913, and in his crude cartography, Carver's Cave resembled the stomach of a cow with its various chambers. The Burnley map would be the starting point for others many years later. Getting into

those rooms—especially that elusive and spectacular waterfall room at the very back—was quite a draw.

Carver's Cave was repeatedly lost to sight over the years owing to detritus sloughing down from the bluffs above. On September 16, 1977, the cave was again relocated and opened with a backhoe as part of an official city bicentennial project, and Native Americans visited it the next day. Double steel doors were erected, which in the coming decades were themselves buried by a debris fan of the sloughed detritus.

In 1991, a California photographer, inspired by local historical novelist Steve Thayer, author of *St. Mudd*, which includes a scene involving a chase through Carver's Cave, explored the first chamber with scuba gear but claimed that his bulky air tanks prevented him from getting through the small aperture into the rooms beyond. In 2016, the 250th anniversary of Carver's first visit to the cave, remotely controlled floating rovers with lights and video recorders were used to produce YouTube footage of the remote corners of the cave. Human explorers, whose feet stirred up the fine silt on the bottom of the subterranean lake—thus clouding the water—could not

Carver's Cave, looking out the entrance in modern times. *Josh Peterson, 2015.*

get this clarity of footage. Old graffiti could be read below the water line, and it was hoped that petroglyphs, too, would be found.

The subterranean lake in Carver's Cave is home to many organisms. The populations of amphipods (also called scuds or freshwater shrimp), pigmented isopods, white flatworms and various gastropods seem to be supported by the leaf litter that blows in through the entrance and decays in the lake. The scuds partake of this detritus, or "junk food," in turn supporting other creatures. The cave also serves as an overwintering refuge for frogs and mosquitoes. Beavers have been observed inside the cave amassing stick caches. But the blind crayfish have not been seen since their 1913 debut.

In 2005, Carver's Cave became the centerpiece of the new Bruce Vento Nature Sanctuary, named for the congressman who represented the East Side of St. Paul for many years.

Another, smaller twin of Carver's Cave exists nearby. Dayton's Bluff Cave—complete with a subterranean lake—is located 390 feet upriver. But unlike Carver's Cave, it remains buried beneath the shifting sands of the Bruce Vento Nature Sanctuary, its location marked in springtime by the colorful yellow bouquet of marsh marigolds that thrive on seepage from the buried mouth of the cave.

Fountain Cave

On July 16, 1817, on his way up the Mississippi River from Prairie du Chien to reconnoiter the Falls of St. Anthony, and again the following day on his way back down, Major Stephen H. Long (1784–1864), of the newly created U.S. Corps of Topographical Engineers, disembarked from his "six-oared skiff" in what is now St. Paul to explore something mysterious that perhaps the local Dakota bands had told him about.

A few miles below the confluence of the St. Peter's and Mississippi Rivers there was a gap in the bluffs where a small stream, later dubbed Fountain Creek, met the great Father of Waters. Disembarking, Long and his men ascended the ravine for more than one hundred yards. They came to a natural amphitheater of snow-white sandstone whose walls, forty feet high, formed three-fourths of a circle, making it seem as though they were standing at the bottom of a gigantic pit. Swallows darted from innumerable holes in the cliffs. The creek issued from a Gothic cave entrance sixteen feet high and about as many wide.

They passed through the cave's pearly-white gates and entered a large winding hall about 150 feet long. The sharp drop in temperature came as a welcome relief on this hot summer day. At the far end of the room, they crawled through a narrow passage that opened into "a most beautiful circular room" about 50 feet in diameter, where their candles flickered against the walls.

"The lonesome dark retreat," Long later wrote in his journal, was cheered by the "enlivening murmurs" of the "chrystal [sic] stream." Wading in icy cold water up to their knees, the soldiers continued along the meandering passage, encountering more rooms of a circular form and penetrating about two hundred yards before their candles went out. They halted, and began to grope their way back in stygian darkness. The U.S. Army, in the persons of Major Long and his men, had just discovered what was thereupon named the Fountain Cave. This writer shares Long's opinion that Fountain Cave is "far more curious & interesting" than the nearby Carver's Cave, which he had visited earlier that same day.

Other explorers soon followed. Henry Rowe Schoolcraft (1793–1864) visited Fountain Cave in 1820, recording his observations in the *Narrative Journal of Travels*, published the following year. Mistakenly assuming that he had found Carver's Cave, Schoolcraft was understandably puzzled by the bizarre metamorphosis the cave seemed to have undergone in the half century since Carver had explored it. Even though Fountain Cave was supposedly located in a "howling wilderness" at the time, Schoolcraft was able to comment upon "the number of names found upon the walls." Nothing loath, he added his own.

Schoolcraft was at this time mineralogist to Governor Lewis Cass's expedition to the headwaters of the Mississippi. He reported that Fountain Cave contained "small pebbles of so intensely black a colour as to create a pleasing contrast [with the white sand], when viewed through the medium of a clear stream." This was the first suggestion of an upstream entrance to the cave somewhere.

On July 5, 1831, in celebration of Independence Day, Joseph R. Brown and others brought a cannon downriver from Fort Snelling and discharged it from within the mouth of Fountain Cave, nearly collapsing the arch. They explored the cave "for a distance of nearly one mile, when they reached a precipitous water fall. Here their candle burnt out." They had another—but no means of lighting it. "After long retrogression," the writer continued, they regained "the light of the sun."

Joseph N. Nicollet (1786–1843), the French émigré scientist who drafted the so-called mother map of Minnesota, visited Fountain Cave in 1837. It

is marked "New Cave" on this famous 1843 map, *Hydrographic Basin of the Upper Mississippi River*. In the report that accompanied the map, he stated, "The cave now referred to is of recent formation. The aged Sioux say that it did not exist formerly." This went beyond even the statement of Long in 1817 that "the Indians formerly living in its neighbourhood knew nothing of it till within six years past." The idea of recentness apparently influenced the Native American name for Fountain Cave, "the new stone house," as transliterated in the official journal of Cass's expedition, not published until 1895. It may be that Nicollet's name for the cave was nothing more than an abbreviated form of the aboriginal designation.

It is more likely, however, that Fountain Cave was not "new" at this time, merely newly reopened. The cave entrance had been concealed by collapsed debris, it may be conjectured, and was flushed open again by Fountain Creek in 1811. But Nicollet was right on the mark when he described *how* the cave had formed. The disturbed geology of the Fountain Cave site is nowhere better described than in his posthumous papers, which were included in Schoolcraft's massive volumes on the Indian tribes of the United States. Briefly, Nicollet noted that the cave had managed to divert a surface stream (Fountain Creek) into itself, which helped to flush out and enlarge the sandstone passage. In 1932, St. Paul landscape architect George L. Nason added the finishing touch to our present understanding of the cave when he described how the ravine at the cave's entrance—"the beautiful little valley," as he lovingly called it—was "formed by the caving in of the roof at various times."

Fountain Cave inspired legends. When Canadian visitor Peter Garrioch explored it in 1837, he recorded in his diary a story he had heard about how "a soldier and two Indians formerly penetrated so far into this cave that they were never heard of any more." It was something that Garrioch himself could relate to. While deep in the cave, his torch had gone out—in the best Fountain Cave tradition—and it was with some anxiety that he escaped from "the gloomy and direful abode of spectres, hobgoblins, and other sweet and tender creatures of fancy."

By the time the famous Pierre "Pig's Eye" Parrant—depicted with his pirate-style eye patch on countless beer cans in our own day—arrived on the scene, also in 1837, Fountain Cave already had a respectable bibliography. The 1837 treaty with the Ojibway having opened for settlement the triangle of land between the St. Croix and Mississippi Rivers, Parrant staked a claim at this cave because it was the nearest point to Fort Snelling that was not actually on the military reservation, thus shortening the distance for the soldiers to whom he sold whiskey.

Parrant was a French Canadian voyager who attempted sedentary habits in his old age, but he did not actually live in Fountain Cave. On the contrary, much of his supposed historical importance rests in the fact that he erected a log cabin, one of the first buildings on the site of what is now St. Paul, on or about June 1, 1838. Often loosely described as a "saloon," it was sited at the mouth of the secluded gorge so that potential customers could see it from the river. Some squatters at Camp Coldwater, near Fort Snelling, soon moved downriver to join Parrant, and cabins began to sprout like mushrooms at the cave. But since the platting of the city of St. Paul actually began in 1849 with "St. Paul Proper," in what is now the downtown area, and not at Fountain Cave, the traditional claim that Parrant founded the city is dubious.

Parrant soon lost his claim through a mortgage foreclosure of sorts, and from this transaction we learn that Fountain Cave was worth ninety dollars. His fellow settlers were evicted in 1840 when the Fort Snelling Military Reservation was resurveyed and expanded.

Strange things were reported of Fountain Cave about this time, providing the first Minnesota ghost stories. "In later years," a 1920 newspaper clipping claimed, "children of the settlers playing within its chambers heard shrieks of the dying Indians, just as they had occurred hundreds of years before, when put to death by their enemies and saw white-robed spectres floating from chamber to chamber, it is said. Even now, after one has found his way down the tortuous sides of the river bank to the spot where a few fishermen's cottages still stand, children of the neighborhood will tell of the strange happenings that go on in the ravine at the mouth of the cave."

The geologist David Dale Owen visited Fountain Cave in 1848. Having been educated in Switzerland, Owen poetically compared the snowy whiteness of the St. Peter Sandstone cave to a glacier cave. It was Owen, indeed, who coined the very term "St. Peter Sandstone," based on his study of rock outcrops along St. Peter's River—now the Minnesota River—at Fort Snelling.

The years from 1850 to 1880 were Fountain Cave's golden age. It became a fashionable Victorian cave—the first commercial or show cave in the upper Midwest. A correspondent for the *Minnesota Pioneer* described the steamboat *Dr. Franklin* loading barrels of cranberries at Fountain Cave, at the entrance to "a fairy little dell," and one of the rooms in the cave as being "more beautiful than could be made with all the wealth of Astor" on December 12, 1849.

Minnesota governor Alexander Ramsey himself went spelunking there, as related in Elizabeth Ellet's *Summer Rambles in the West*, published

in 1853. "A rustic pavilion stands in the woods," she wrote, "where lights can be procured to enter the cave." A footbridge over the ravine had been constructed. She compared Fountain Cave, which she called "Spring Cave," to "a marble temple" and its stream to "a shower of diamonds." Frederika Bremer, in her *Homes of the New World* (1853), described Fountain Cave as "a subterranean cavern with many passages and halls, similar probably to the celebrated Mammoth Cave of Kentucky. Many such subterranean palaces are said to be found in Minnesota." A letter to the *Congregationalist* of Boston for September 19, 1856, described a visit to the cave, mentioning "the torch of birch-bark which your guide manufactures for the occasion."

The most elaborate account of Fountain Cave at this time was presented by the Galena, Illinois journalist E.S. Seymour in his *Sketches of Minnesota, the New England of the West*, published in 1850—a version that was to be reprinted more than any other in the coming years. Seymour's description establishes that the cave was basically an unbranched tube, wholly in the sandstone layer. Apart from widenings of this passage, called rooms, much of the passage was crawlway. There were four rooms successively decreasing in size upstream, of which he gave the dimensions. The third room back was the only named feature in the cave, called "Cascade Parlor" because it contained a waterfall two feet high; he suggested planking over the stream here to make it more accessible to visitors. He did not go beyond the fourth room, having penetrated an estimated distance of sixty rods (990 feet), but stated that he could hear a second waterfall in the distance.

The oldest known graphic depiction of a Minnesota cave is a pencil and watercolor of Fountain Cave by an unknown artist, looking into the entrance, about 1850. Adolph Hoeffler, a German landscape artist, soon responded with the first view looking out, a small woodcut in his "Sketches on the Upper Mississippi," published in *Harper's New Monthly Magazine* for July 1853.

The German landscape artist Henry Lewis (1819–1904) painted scenes along the Mississippi River from St. Anthony to the Gulf of Mexico, and he has a separate entry for Fountain Cave in his book *Views of the Mississippi*, originally published in German in 1854. Much of his information about the cave appears to have been borrowed from others. Lewis calls the local bluffs "The Cornice Cliffs," perhaps an allusion to how erosion has sculpted them into pseudo-architectural forms.

Another German, the prolific geographer Johann Georg Kohl, visited Fountain Cave in 1855. "It is called Crystal Cave," he wrote, "because the small stream that bubbles out of it is clear as crystal. The entrance is a true

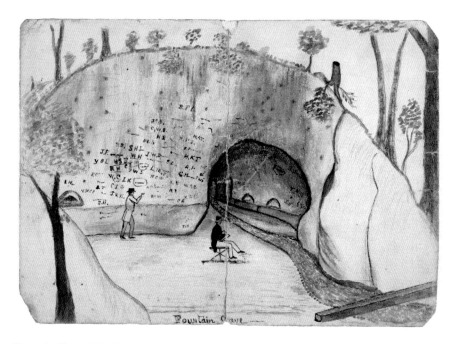

Fountain Cave, 1850. Pen and watercolor by unknown artist, the earliest depiction of a Minnesota cave. *Minnesota Historical Society.*

painter's dream." But "sand has other uses," he continued mundanely, "and a glass factory will soon be built here." "The cave twists deep underground," he added. "In its depths can be heard a hissing and boiling as in a kettle, said to come from subterranean falls of the stream that exits the cave."

In 1857, during the fever of real estate speculation that smote early St. Paul, the present Grotto Street was platted. It was said to have been named after Fountain Cave, because if the street were extended, it would supposedly strike the river at the cave. In fact, it would miss by a half mile. A plan by the Junior Pioneer Association of St. Paul to construct a "fine boulevard approach" to the site in 1920 would have been more deserving of the name, but nothing came of it.

An article in the *Knickerbocker, or New-York Monthly Magazine*, for October 1857, offers a more jaundiced view of the commercial heyday of Fountain Cave:

> *In its primitive simplicity it was doubtless a beautiful place, opening as it does in a deep glen near the Mississippi, and surrounded with luxuriant verdure. But that rapacity which exhibits itself in all the walks of life,*

has made its appearance here; and the spot, being "private property," now rejoices in a little seven-by-nine shanty, where, "for a consideration," you may obtain a "guide" and a tallow candle, and upon returning from your explorations, for another "consideration" some fiery brandy and a rank segar. Aside from that, the place has lost much of its old charm, for during the summer months it is thronged with visitors daily; the paths leading to it are dusty and travel-worn, and the soft, white sand-stone walls are marred all over with the names of the Joneses and Browns who have honored "the Cave" in the "grand rounds." Why is it, by-the-way, that so many Americans seem to think it an imperative duty when they visit a place of any note, to leave behind them, for the edification of after-comers, through the instrumentality of the omnipresent jack-knife, their common-place names, and in the most staring capitals possible?

By the end of the American Civil War, however, the less desirable tourist trappings of Fountain Cave had melted away. A Danish visitor, Robert Watt, reported in 1871, "Fortunately nothing has been done in the way of artificial embellishment, no obtrusive guide presents himself for service, and a person can enjoy peacefully and quietly the sight of this mysterious opening in the earth." He thought that he might "penetrate a couple of miles beneath the surface either by canoe or by picking his way along the narrow white sand edges of the stream." Most photographs of Fountain Cave are stereoscopic souvenir views from about this time. Those by William H. Illingworth are classics, giving you a good feel for the roominess of the original cave.

A tourist guidebook by James Davenport published in 1872 reveals that directions to Fountain Cave from downtown St. Paul were surprisingly uncomplicated: "the route being out Fort Street to the outskirts of the city, and then by turning to the left down to the river bank." By 1879, Fountain Cave was featured in *Tourists' Guide to the Health and Pleasure Resorts of the Golden Northwest*, published by the Milwaukee Road, and one of the engravings shows the most elegantly dressed cave visitors of all, complete with top hats and walking sticks. In 1881, William H. Dunne published *The Picturesque St. Croix and Other Northwest Sketches Illustrated*, one of the last travel guides to suggest a trip into Fountain Cave. However, an accompanying engraving depicting boats inside the cave was actually a recycled depiction of the Cave of the Dark Waters, in the Wisconsin Dells.

The Victorian version of the modern Grand Rounds thus placed visitors much more in contact with our local caves and waterfalls than with shopping malls. But Fountain Cave was no longer on the itinerary. In 1880, the newly

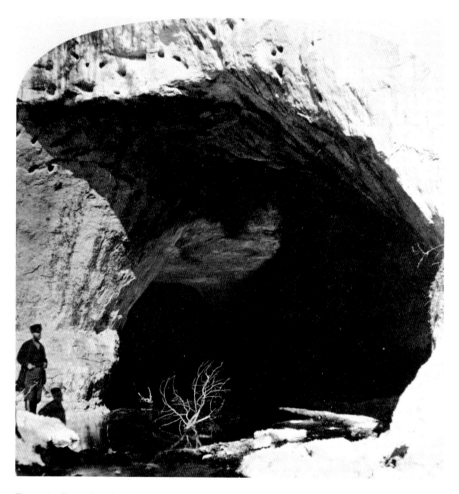

Fountain Cave, showing the subterranean stream, by Illingworth, circa 1875. *Trustees of the Boston Public Library.*

formed Chicago, St. Paul, Minneapolis and Omaha Railroad—called the Omaha, for short—began building a roundhouse and repair shops in the triangle of land bounded by Randolph, Drake and the river. The oldest and only complete map of Fountain Cave known to exist, the A-41 map, dates to the 1880s and shows this facility already in place. Judging from the A-41 map, Fountain Cave is the longest (but not the largest, in terms of volume) natural sandstone cave in Minnesota, about 1,100 feet. The railroad mapped out the underlying cave only so it could use the cavern as a sewer for the overlying shops.

As the years rolled past, local memory of Fountain Cave grew hazy, approaching sheer fantasy. In 1945, Mark Fitzpatrick, in his "Forgotten Facts about St. Paul" column for the *St. Paul Shopper*, for example, wrote, "In early times one entering the grotesque lunar shape mouth of the cave beheld a magic island with a natural fountain playing dreamingly with its hazy spray and misty prismatic rays. On all sides of the main entrance were labyrinth chambers deep in size and overhung with drooping stalagmites of a unique conception." Beautiful imagery to be sure, but never mind that stalagmites grow from the floor, not the ceiling.

In 1960, the original natural entrance to Fountain Cave, the one used by so many famous explorers, was sealed by the highway department. The construction of Shepard Road along the river bluffs, begun years earlier, was intended to create "a fast route downtown" from the Minneapolis–St. Paul Airport. Unfortunately, the cave ravine lay directly in the path of the new highway, providing the engineers with a good place to dump "surplus excavated material." The Minnesota Historical Society erected a historical marker for Fountain Cave over the buried ravine in 1963.

What had become of the stream that gave the cave its fountain? State geologist N.H. Winchell reported in 1878, "The water that issues at Fountain Cave, St. Paul, is that of a creek which disappears in the ground about half a mile distant." On the A-41 map, Fountain Creek is shown flowing into a sinkhole near the Omaha Railroad shops. It flows through the cave as a dashed line and reemerges in the ravine, entering the Mississippi. Other early maps indicated that the ultimate source of Fountain Creek was the old Fort Road wetlands to the west, long since paved over.

Old real estate plats allowed me to pinpoint the exact location of the sinkhole shown on the A-41 map. In 1923, a railroad spur servicing the Ford Motor Company plant in Highland Park was built right over the spot, meaning that the "upper entrance" to the cave, if ever humanly enterable, was now sealed. Once the Fort Road wetlands and the sinkhole were built over, the water supply to the cave was cut off, and cliff debris began to accumulate at its entrance—debris that ordinarily would have been flushed away by the cave stream itself. What historian Newson said of Carver's Cave, that it was "slowly dying of civilization," could also be applied to Fountain Cave.

Trophonian Cave

The Trophonian Cave is a purely imaginary hybrid cave cobbled together in the mind of Italian explorer Giacomo Beltrami (1779–1855), based on his visits to Carver's and Fountain Caves in St. Paul. An Italian exile, Beltrami arrived at Fort Snelling on the very first steamboat to dock there, the *Virginia*, in 1823, and attached himself to Major Long's second expedition to what is now Minnesota, sent to investigate the Canadian border. Beltrami began quarreling with Long and struck out on his own, carrying his trademark red umbrella while searching for the source of the Mississippi River, which he claimed to have identified, years before Schoolcraft's identification of the true source at Lake Itasca, in 1832. Beltrami County, Minnesota, is his other, more enduring, memorial.

Passing through what is now St. Paul on his travels, Beltrami confounded Carver's and Fountain Caves in his memoirs, *A Pilgrimage in America*, published in 1828, producing the hybrid Trophonian Cave. The physical description of Beltrami's cave undeniably belongs to Fountain Cave, yet he attributed to it Native American ceremonies and the "hieroglyphics" (petroglyphs) associated with Carver's Cave, even using the name "Whakoon-Thiiby" (Wakan Tipi) which signifies the latter cave. In any case, Beltrami certainly gives the most elaborate description of the Native American religious rituals at this cave, laced with classical allusions, as was the fashion of the day:

> *On the 19th* [May 1823] *we stopped to take in wood. I was told of a cavern, which was only at a short distance from there, and about twelve miles above the encampment of the Marsh. A small valley on the east leads to it. Cedars, firs, and cypresses, seem to have been purposely placed there by nature, that the approach might bespeak the venerable majesty of this sacred retreat. The entrance is spacious, and formed in lime-stone* [sic] *rock, as white as snow. A rivulet, as transparent as air, flows through the middle. One may walk on with perfect ease for five or six fathoms, after which a narrow passage, which however is no obstacle, except to those apathetic beings whom nothing can excite, conducts to a vast elliptical cavern, where the waters of the rivulet, precipitating themselves from a cascade, and reflecting the gleam of our torches, produced an indescribable effect. You climb to the top of a small rock to reach the level of the bed of this Castalian spring, whose captivating murmur allures you onwards, in spite of the difficulties which impede your progress, and you arrive at its*

source, which is at the very end of the cavern. It is calculated that it is about a mile in length....The savages assemble yearly in this cavern, to perform their lustrations; and, what is more remarkable, at the same season, that is to say, in the spring; and in the same manner, by water and fire, as the Catholics, the Peruvians, and the ancients. They plunge their clothes, arms, medicine bags, and persons, in the water of this rivulet; they afterwards pass their arms and clothes, together with their medicine bags, through a large fire, which was not extinguished at the time of my visit. This ceremony is always accompanied with a dance round the sacred fire, in a mystic circle, like the medicine dance. It appears that this lustratio is their corporeal purification. The cave is appropriated to other ceremonies in the course of the year. The Indians assemble there to consult either the Great Manitou or their particular Manitous; and their chiefs, like Numa Pompilius, can make their nymph Egeria speak whenever they want to prevail on a reluctant people to obey them. They perform all their lustrationes before they consult the oracle, as the Greeks did before they entered the cave of Trophonius. The Sioux call this cave Whakoon-Thüby, or the abode of the Manitous. Its walls are covered with hieroglyphics: these are perhaps their ex-voto inscriptions. This cavern has one great advantage over those of antiquity; credulity is not here an object of traffic.

Beltrami's Trophonian Cave was ultimately based on the Cave of Trophonius, a famous Greek cave that could be entered by descending a ladder. It contained an oracle that was consulted into Roman times and is well described and depicted in W.H. Davenport Adams's *Famous Caves and Catacombs*, published in 1886. Adams reports that "it became proverbial in Greece to say of any person who appeared grave and anxious, 'He has returned from the cave of Trophonius.'" According to other sources, the cave contained an underground river—just like Fountain Cave.

MILES CAVE

The river town of Hastings, Minnesota, is underlain by a vast natural labyrinth, according to the local mythology. Others believe in a smaller version of this labyrinth, one that connects Miles Cave, a natural cave in the bluffs of the Vermillion River, with the basement of the Le Duc House, a nearby mansion. The cave is much shorter than most people realize, about

five hundred feet of dusty crawling passages, none of which reach even so far as the mansion. Caver and fossil collector Tim Stenerson (1960–2017) of Red Wing, Minnesota, who contributed so much to documenting and mapping the smaller, seldom-visited caves of Minnesota, spent many happy hours digging out the crawlways of Miles Cave, always hoping for that elusive connection to the Le Duc mansion.

Miles Cave was reportedly named after General Nelson Appleton Miles (1839–1925) of Civil War fame. According to one witness, "I was told by early settlers that the Indians often used this cave. Also, that it was named after General Miles who used the cave in his dealing with the Indians, and his successful ventures in Indian outbreaks. This is how it finally received its name." I have often felt that General Miles's association with the Battle of Wounded Knee provides an apt metaphor for anyone trying to crawl through this rocky-floored cave.

The historic Le Duc House, on the other hand, was named after William Gates Le Duc (1823–1917), the U.S. commissioner of agriculture under President Rutherford B. Hayes. During the candlelight Halloween tours of this mansion, conducted by the Dakota County Historical Society, a patch on the basement wall is often pointed out as where the connection to Miles Cave used to be.

Miles Cave is located in the Oneota dolomite layer downstream from the falls of the Vermillion River, in a city park near an old flour mill. The non-geologist might be tempted to interpret this natural maze cave as a space in an ancient coral reef that—when it formed in ancient seas—looked much like the underwater caves where the villains hid the stolen atomic bombs in the James Bond movie *Thunderball*. But in fact, the rock represents an ancient algal reef on a tidal flat—a much less picturesque sedimentary scenario.

The largest room in the cave is the so-called Party Room, which with its natural rock benches served as a cave classroom for my Speleology 101 course, offered through the University of Minnesota years ago. The room is adorned with flowstone and cave pearls, which form where sand or gravel gets coated with calcite and becomes rounded because of the impact of falling water droplets. Centrally located, crawlways radiate out from this room like the spokes of a wheel, one of them leading to an exit in the open fields above. During especially cold winters, the cave grows a forest of club-shaped ice stalagmites.

So much for the eastern half of Miles Cave. The western half is much tougher to get to, either by a dangerous cliff climb or through the Carcass Crawl, where an unconfirmed date of 1848, discovered by Stenerson, has

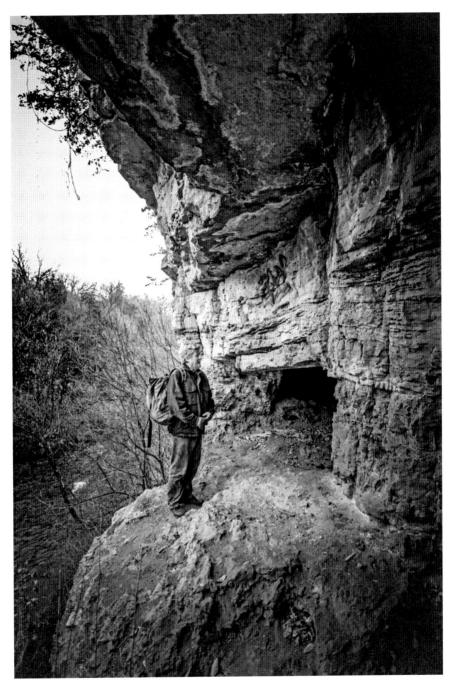

Entrance to a legendary labyrinth, Miles Cave, overlooking the scenic Vermilion River at Hastings, Minnesota. *Tony Andrea, 2016.*

been carved in the ceiling. The chilly pools of water, raccoon carcasses and scats that carpet this lengthy claustrophobic crawlway are powerful dissuasions to those passing over to the other side. Not to mention the prospect of encountering a disgruntled raccoon somewhere in between!

In addition to raccoons, the author has observed housecats prowling the forlorn passages of Miles Cave. Perhaps they have found the secret connection to the mansion?

JESSE JAMES CAVE

The Confederate bushwhacker and later bank robber Jesse James (1847–1882) is associated with many locations in the Midwest, often for touristic reasons. While there is thus more than one Jesse James Cave, even in Minnesota (see "Seven Caves," page 117), one of his hideouts was reportedly a crevice in red quartzite in what is now Blue Mounds State Park, near Luverne, Minnesota. Other void spaces in the rocky outcrops frame picturesque views of the surrounding tallgrass prairie.

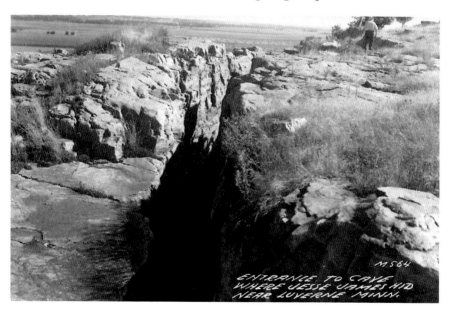

Above: Jesse James Cave, in the red quartzite outcrops of what is now Blue Mounds State Park. *National Cave Museum, Diamond Caverns, Park City, Kentucky.*

Opposite: Quartzite cave at Blue Mounds near Luverne, Minnesota. *National Cave Museum, Diamond Caverns, Park City, Kentucky.*

History & Lore

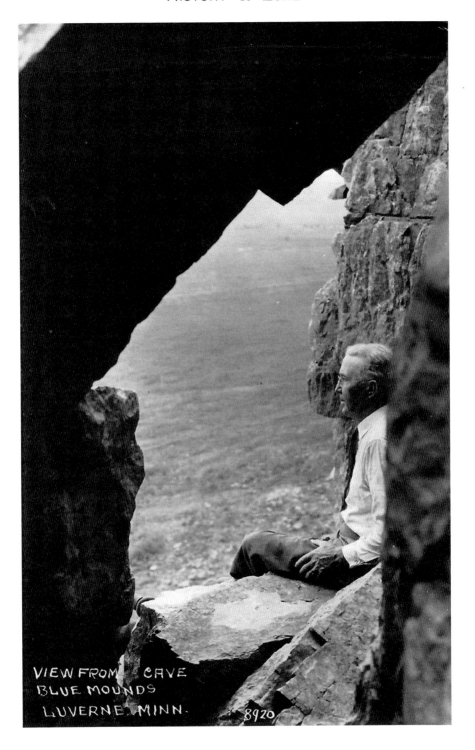

VIEW FROM CAVE BLUE MOUNDS LUVERNE, MINN. 8920

QUARRY HILL CAVE

Rochester State Hospital, in Rochester, Minnesota, was founded as an asylum in pioneer days, becoming Minnesota's lobotomy capital after World War II. The surgery done upon a hill of gray and white matter on the hospital grounds was no less extensive. From 1882 onward, 380 feet of passages were carved in the white St. Peter Sandstone in a horseshoe pattern inside a hill capped by the gray Platteville Limestone. The limestone was quarried to construct the hospital buildings and gave its name to the hill. Originally dug as a giant root cellar for storing vegetables over the winter, the unique feature of these sandstone passages is that they are segmented into separate stalls where bins of vegetables were placed. Canning and electric refrigeration eventually made the cave cellar redundant, and it was abandoned by the 1950s.

Quarry Hill Cave is now protected as the showpiece of the Quarry Hill Nature Center, established in 1972, and its excellent displays are well worth a visit. The cave entrance is firmly gated, partly to protect historic features, such as the poetry of "Coyne the Prophet," leader of the digging parties,

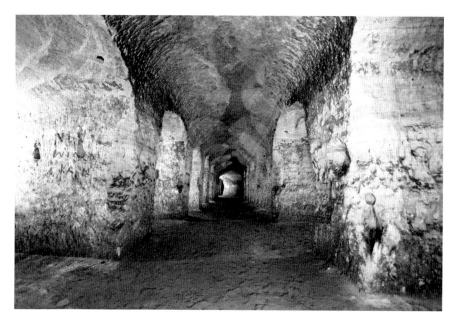

Quarry Hill Cave, a giant root cellar dug from the St. Peter Sandstone at Rochester, Minnesota, by hospital inmates. *Quarry Hill Nature Center.*

who carved poetry upon the walls, creating an asylum within the asylum, so to speak. Educational tours of the cave are given on a regular basis, and the cave is decorated for Halloween, with the unique feature of separate scary tableaux in each stall. Nearby, Horse Thief Cave, dug on a similar plan, has the same feature of individual stalls—but for livestock—and was rumored to have been used by horse thieves in pioneer days. It was partially filled in years ago, owing to the wild parties of college students.

3
BREWERY CAVES

In years past, many people who had a casual interest in visiting the St. Paul underworld—perhaps to party wildly away from the prying eyes of parents or from public scrutiny in general—chose to do so in the abandoned brewery caves below the city's various neighborhoods. The very caves that were once used to produce beer, back in the late nineteenth century, thus became the chief place of its consumption in the twentieth.

Between 1840 and 1870, German immigrants to the United States brought with them their traditional fondness for beer, which had not previously been of great importance in this country, where hard liquor was usually preferred—something that has been called the "beer invasion." Ironically, this invasion was apparently facilitated by temperance agitation, which originally focused largely on "ardent spirits," leading many Americans to choose the less potent beverage as a substitute.

Prior to 1840, according to many histories of the subject, there were no breweries in America producing the German-style lager beer. Lager beer differed from the prevalent English and American beers, such as ale, in that the lager yeast fermented at the bottom of the vat, rather than the top, and the beer required lagering, or storage, for several months at lower temperatures. In the old days, lager beer could only be brewed during the winter months, when cellar temperatures were sufficiently low. But in northern states, such as Minnesota, where natural ice was readily available, ice cakes could be harvested from nearby lakes and rivers in winter and stacked in caves, allowing brewing year-round to meet the growing demand.

YOERG

Minnesota's first brewery, which produced lager beer, was established in 1848 by Anthony Yoerg, in St. Paul. Yoerg, like many St. Paul brewers to come, was a native of Bavaria, the cradle of the German brewing industry. It wasn't until 1871 that Yoerg moved to the location that was to be so closely associated with his name, on the opposite side of the Mississippi River.

Yoerg's Brewery was built in a snug little cove along Ohio Street, an idyllic spot once referred to as "The City of the Birds" from all the holes that cliff swallows had dug in the sandstone bluffs. St. Paul historian Edward D. Neill was able to report by 1881 that Yoerg "has five cellars excavated in the bluffs." The brewery prospered mightily until Prohibition came along, when it eked out a meager existence as the Yoerg Milk Company in the face of stiff competition from existing milk companies.

Many of Yoerg's newspaper advertisements after Prohibition featured Rip Van Winkle awaking from his slumbers, showing the elves rolling the kegs out of the cave. Unfortunately, the caliber of management had declined in the interim. Yoerg stuck to its lagering caves long after other breweries had moved beyond this technology, producing its "Cave Aged Beer," as proudly advertised on cone-top cans—which were themselves a late adoption by the company.

Yoerg's Brewery closed in 1952, and the lagering caves were rented to the Charles Harris Plumbing & Heating Company, which used them for the storage of plumbing fixtures. Thereafter, Yoerg's Cave acquired an interest for the urban tourist akin to what the famous glowworm caves have become for the tourist in New Zealand. Glowworms are a sort of luminous fly larva that make a living in certain New Zealand caves by attracting other flies to their lights, trapping them in a sticky web, like a spider would do. At Yoerg's Cave, the light was generated very differently, involving something known as piezoelectricity.

Here's how our illuminating tale unfolds. After fire tore through the plumbing warehouse in 1958, Harris moved away, leaving toilet bowls stacked up to the ceiling in the cave passages. But by the time I explored Yoerg's Cave in the late 1980s, nothing but broken shards were visible. Apart from the entropy of boredom, the whole reason for busting the bowls, according to eyewitnesses, was to enjoy the shower of sparks that the disintegrating porcelain emitted in the dark—a display of piezoelectricity.

By 2004, Yoerg's Cave was ready for another glowing tribute. The cave became a lobbing ground for Molotov cocktails, footage of which appeared

on the television news. Others, digging inside the cave on a recreational basis, found old boxes and burlap sacks containing gunpowder from the 1950s, which the St. Paul Bomb Squad promptly removed. According to my own tests, however, the gunpowder was degraded and incapable of ignition. That was probably fortunate for all concerned, lest the City of the Birds once again become airborne.

BANHOLZER

The Fort Road neighborhood of St. Paul was especially known for its breweries. In 1871, Frederick Banholzer acquired the North Mississippi Brewery, which had been established in 1853. In 1886, Banholzer Park, a beer garden, opened, buoyed up with balloon rides to Lilydale across the river. After Frederick's son William died, the brewery declined, going out of business in 1904.

Banholzer Cave was the king of party caves before it was sealed in 1991. No one called it Banholzer Cave, though; it was known locally as Frankenstein's Cave. One well-known entrance to this cave, the Sumac Street sewer outfall, was located on the river bluff. The determined partier of yesteryear, bent double with kegs, could shuffle through the brick sewer, chasing the rats ahead of him, until coming to a hole in the wall, by means of which he entered the cave. Or, he could brazenly come in through the cave entrance on the other side of Shepard Road, where there was a garage-like shed that opened into a long, gently sloping passage leading into the heart of the cave.

The fact that this great party cave had two good entrances (or shall we say exits?) led to some interesting encounters with law enforcement. I heard that there was once a police raid where tear gas was fired into one entrance, and when the partiers tried to exit the other way, they ran right into the waiting arms of the police.

Banholzer Cave consists of a large grid of passages arrayed in a "fingers and thumb" pattern similar to that of Yoerg's Cave, about a half mile in length and large enough to drive a truck through. More of the rooms had special names than in any other brewery cave, which is characteristic of party caves. The late newspaper columnist Don Boxmeyer recalled this gleeful "boy's world" from his youth, describing locations like King's Cave, Three Sisters (three parallel passages), Frankenstein's Bedroom, the Bear Hole and the Dump. The cave then experienced the names

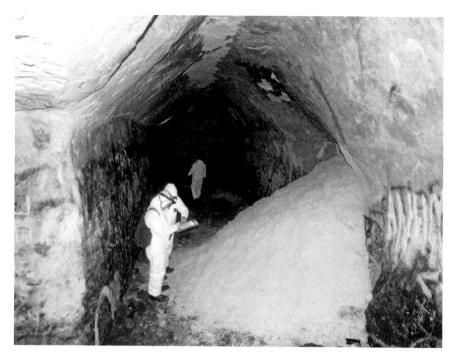

Banholzer Cave, a former lagering cave in St. Paul. The scientists are performing a bat count and investigating cures for white-nose syndrome. *Dr. Christine Salomon, 2015.*

bestowed by a generation of Tolkien readers, inspired by that author's tales of Middle Earth, names such as the Mines of Moria. Later still, cave features such as the giant red Pegasus mural, the Weary Sage carving and the High Baroque Altar inspired literature of their own, including the romantic short story of the lonely nuptials of a ghostly Christmas bride in the smoke-blackened vaults.

But perhaps the most hilarious confusion resulted from the wedding of Banholzer Cave with the historic Fountain Cave. In the old caving club newsletters I found reference to a "Fountain Beer Cave," continuing the tradition of hybrid caves when two caves are in proximity.

Banholzer Cave extended below Shepard Road, a busy trucking route, subjecting it to incessant vibration. An ominous snowfall of white sand grains into one's hair was noticeable when vehicles passed overhead. In 1991, Shepard Road was widened and repaved, and the authorities took the opportunity to seal the cave, which had given them so much grief over the years. Chain-link fencing was wrapped into the entrances and concrete was poured into the mesh. The ceilings were collapsed in from above and the

underlying voids slurried full of sand, pumped in through hoses. Almost as soon as the cave was sealed, however, local diggers made extensive attempts to reopen the remaining rooms, which they eventually did a generation later. One unexpected benefit was that the cave was soon repopulated by bats using it as a winter hibernaculum.

Stahlmann's Cellars

By contrast with Banholzer Cave, Stahlmann's Cellars has never been a party cave and is the only one among those described here that has had an active brewery associated with it in recent times. As such, the cave's walls are devoid of graffiti, and the rooms are unnamed. No past generations offer stories about playing on the clean, sandy floor, devoid of broken beer bottles. It took me some time even to find a way into the cave, by tracking the brewery discharges up through the sewers, back in 1999. But the cave has a fascinating history.

In 1855, Christopher Stahlmann established the Cave Brewery on Fort Road (aka West Seventh Street) in what was then the outskirts of the city—what would later become the Schmidt Brewery. Newson, in his *Pen Pictures of St. Paul* (1886), described Stahlmann thusly: "He was born in Bavaria in 1829; came to the United States in 1846 and…removed to St. Paul in 1855, and erected his brewery the same year. He was a member of the House of Representatives in 1871 and in 1883; was [Ramsey] County Commissioner in 1871, and held several other minor offices." Describing Stahlmann's commercial enterprises in more detail, Newson wrote, "In early days he went out to what was known as the old Fort road, now [West] Seventh street, and purchased several acres of land there and built his brewery thereon. These acres were then considered away out of the city, but are now within the city limits and very valuable." Stahlmann was indeed "one of the greatest pioneers of the West End."

With the growth of the beer market following the Civil War, Stahlmann's Cave Brewery, as it was known, became the largest brewery in Minnesota. As the name "Cave Brewery" suggests, Stahlmann carved an extensive lagering cave, still known as Stahlmann's Cellars, in the St. Peter Sandstone, below the brewery. In 1877, a newspaper reporter described the cave during its heyday:

> *Armed with candles, and conducted by Mr. Stahlman [sic], the visiting party started down, down into the bowels of the earth; down through the strata of solid lime stone rock which underlies all that section, and of which the buildings are built, we went until we struck the underlying strata of sand rock, fully sixty feet below the surface. Here were the cellars—cellars to the front, the right, the left, and the rear—in all over 5,000 feet, or nearly a mile in length, and still the work of excavating new chambers is going on. These cellars are about 16 feet wide and ten feet in height. In them now are some 120 huge butts of different varieties of beer, in all over 3,000 barrels. The butts are in chambers, six or eight in a line, each group backed by a huge chamber of ice to keep them at proper temperature, in all over 6,000 cakes of the three foot Mississippi ice now being in store. Such complete cellars, dry, fresh and clean, we venture cannot be found elsewhere in America....Fortunately Mr. Stahlman has an inexhaustible supply of the purest of spring water. It is brought in pipes from the bluffs, and carried into every floor of his private residence, feeds the boilers, runs through his cellars, all over the brewery and malt house, and is finally discharged into a sewer with the general refuse, which is discharged into the Mississippi through the cave.*

Atmospheric descriptions like these influenced later writers, until Stahlmann's Cellars acquired a national reputation as the very type of labyrinthine complexity, which it still held more than a century later. As noted by art historian Susan Appel, "The breweries with the best and most extensive cellars became the most famous."

A partial map of Stahlmann's Cellars, dated 1884, was copied onto sewer plats, and it shows two grids of passages meshing at an angle. One grid, somewhat irregular, is aligned with Fort Road, while the other, more rectilinear, is aligned with the real estate plat (Stinson, Brown, & Ramsey's Addition to St. Paul), making 1,400 feet of passages. Additional passages, under the present brewhouse, are shown on a different map, the "Sub Basement Plan," but these may date to another era. The total length of passages is more like half a mile, rather than the mile claimed in the old accounts. Even so, the Stahlmann maze is more extensive than any other brewery cave in Minnesota.

However, the use of caves to trap cold winter air or to fill with ice, for lagering, was becoming obsolete by the 1870s, when brewers began to build icehouses, which "took the aging of lager beer out of caves and placed it in an aboveground stack of 'cellars' cooled by a massive body of ice at the

top of the building." The construction of icehouses bypassed the arduous task of underground excavation. And with the widespread adoption of mechanical refrigeration in the 1880s, ice-making machines freed brewers from dependence on natural ice with its uncertainties of supply and price. The icehouse thus evolved into a mechanically refrigerated stock house, where temperatures could be even more scientifically controlled. Eventually, mechanical refrigeration focused on generating cold air itself rather than ice, avoiding altogether the bulkiness and messiness of the latter.

Another factor favoring the abandonment of lagering caves was the desire for cleaner facilities in the wake of Louis Pasteur's research into the so-called "diseases" of beer. Indeed, the Stahlmann Cave Brewery was incorporated as the Chris Stahlmann Brewing Company in 1884—without the cave moniker.

Today, however, St. Paulites are much more familiar with the Cave Brewery's successor, the great Schmidt Brewery, which towers over the Fort Road neighborhood like a magnificent red brick Rhineland castle. While brewing Bavarian beer in a Rhenish castle might seem odd, this *Rundbogenstil* (round-arched style) architecture was very much in favor at the time. Jacob Schmidt had been born in Bavaria in 1845 and learned his craft at Milwaukee's famous breweries and elsewhere, ending up at the North Star Brewery on St. Paul's Dayton Bluff, which he controlled by 1884. Meanwhile, Christopher Stahlmann had succumbed to "inflammation of the bowels" in 1883, leaving the Cave Brewery in the hands of his competent sons, all of whom tragically perished, however, one after another, from tuberculosis, causing the brewery to go bankrupt in 1897. In 1900, Schmidt, seeking to replace the North Star Brewery, which had recently burned down, purchased Stahlmann's brewery.

Schmidt rebuilt Stahlmann's brewery in 1901–02 with the help of Chicago architect Bernard Barthel, who employed what has been called "the feudal castle style." By this time, progressive brewers regarded the use of caves for lagering as a sign of backwardness. In 1901, for example, Schmidt's chief local competitor ran a newspaper advertisement boasting, "The only brewery in St. Paul that has a modern refrigerating plant is Hamm's Brewery. Beer is stored in rooms kept at a temperature of 35 degrees. Light, pure air and absolute cleanliness help to make the beer pure and wholesome. No dark, ill-ventilated caves; temperature unchangeable and ventilation perfect. Insist on getting the honestly brewed HAMM'S BEER. Annual capacity, 500,000 barrels." Schmidt, whose North Star Brewery had depended on lagering caves at Dayton's Bluff, introduced mechanical refrigeration at the Stahlmann location.

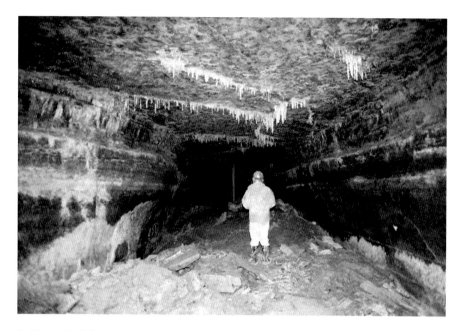

Stahlmann's Cellars, an abandoned lagering cave in St. Paul showing the sandstone walls and limestone ceiling. *Andrew Hine, 2006.*

The Schmidt Brewery had several successors, but in 2002, its latest incarnation, Landmark Brewery, shut down, while Gopher State Ethanol, the nation's first urban ethanol plant, which had begun production at the site in 2000, continued in operation until 2004, when it, too, was shuttered.

Being familiar with Stahlmann's Cellars, I paid a return visit after Landmark Brewery shut down to see what changes, if any, the closure had wrought in the underlying cave. Indeed, the microclimate of Stahlmann's Cellars had changed significantly since the brewery shutdown. Most notably, the cave was much cooler and drier because the brewery was no longer draining hot wastewater through the cave. In the absence of brewery waste, the cave life died off. No rats or cockroaches, which previously swarmed about the cave, were seen this time.

In 2005, the Minnesota State Historic Preservation Office determined that the Schmidt Brewery was eligible for nomination to the National Register of Historic Places and parts of it were repurposed as the Schmidt Artist Lofts. Hopefully, the historic cave found in the depths below can also partake in the vision, commemorating the heritage of the great nineteenth-century German brewers of St. Paul and their endless, fascinating mazes.

HEINRICH

Neighboring Minneapolis had few brewery caves, but Heinrich Cave, now in Riverside Park near the West Bank Campus of the University of Minnesota, is unique. Of all the sandstone caves I've seen, it's unusual for its extensive mineral ornamentation.

Beginning as the Minneapolis Brewery in 1866, the Heinrich Brewery, as it came to be known, existed until 1903. The area was dubbed "Brewery Flats" because the Noerenberg Brewery (whose lagering caves are inaccessible today) was also located nearby. These breweries, along with others, merged to form Grain Belt Beer in the 1890s, which went on to become a nationally recognized brand.

Heinrich Cave was dug in the St. Peter Sandstone, probably in the 1880s, with more than one thousand feet of passages. The three entrances led to three passages into the bluff, these being connected by cross-cuts. In the late 1930s, when the sanitary interceptor tunnel was being dug nearby, the cave was used as a dumping ground for excavated sand—which is why the passages, originally twenty feet high, are nearly full to the ceiling throughout much of the cave, leaving mere crawlspaces. It became a play space for university students, where games of Dungeons & Dragons were held, judging by the earthen forts and plastic swords found about. Heinrich Cave was gated as a hibernaculum for the Eastern pipistrelle bat by the Minnesota Department of Natural Resources (DNR) in 1990 and is closed to the public.

In the remotest part of Heinrich Cave there's the Red Room, studded with reddish rusticles (rust stalactites). The floor here is corrugated with red flowstone with pockets of cave pearls. The reddish color comes from iron oxide. A greenish pool of water in the rear of the Red Room is afloat with calcite rafts. The most unusual mineral found in the cave, however, is gypsum, usually associated with drier and warmer caves farther south. A crawlway at the rear of the cave is adorned with gypsum needles, and gypsum petals can be found on the ceiling nearby. In other places, gypsum wedging has occurred, forcing apart limestone layers in the ceiling, causing them to collapse onto the floor below. It appears that what the Minneapolis brewery caves lack in size and number, they make up for in their unique crystal deposits.

Directly across the Mississippi River from the Heinrich Brewery was another cave, Bromley's. One of the best photographs of the brewery shows it framed looking out from the entrance of this cave. The cave was named after journalist and photographer Edward Bromley, whose article

"Famous Caves Along the Mississippi River Were Scenes of Important Historical Events" for the *Minneapolis Sunday Times*, August 17, 1902, claimed that this natural cave was once inhabited by gypsies. "The crude pictures which in former years adorned its interior and recorded hunting and fishing incidents in Indian history, have been obliterated by ambitious white children who have substituted their initials or those of their school mates," he wrote. It is almost as if the story of Carver's Cave had been transplanted from St. Paul to Minneapolis. Another hybrid cave?

4
MUSHROOM VALLEY

The city of St. Paul—more so than its twin, Minneapolis—is known for its artificial sandstone caves, and the densest cluster of them is surely Mushroom Valley, across the Mississippi River from downtown St. Paul. In that regard, St. Paul's true geological twin city would be Nottingham, England, famous for its many artificial sandstone caves, as described by geologist Tony Waltham.

Mushroom Valley, according to the boast, was the largest mushroom-growing center west of Pennsylvania, or alternatively, west of Chicago. Sometimes it was called the mushroom capital of the Midwest. The mushrooms were grown in the more than fifty sandstone caves that punctuated the bluffs. Although called caves, they were artificial. Begun as silica mines, these caves were subsequently used for mushroom growing and other purposes. According to newspaper columnist Oliver Towne (Gareth Hiebert), "A whole economy and countless legends lie locked from view inside those rustic cliffs." He dubbed them the "Ivory Cliffs" owing to the snowy whiteness of the St. Peter Sandstone.

Used in the broadest sense, Mushroom Valley is divided into three distinct segments: Plato Boulevard, Water Street and Joy Avenue. Each segment has its own distinct flavor. The Plato segment, incorporating what had been the cave-riddled Channel Street before a 1970 replatting reset the street grid, is capped by Prospect Terrace with its historic houses and magnificent views of the city. The Water Street segment, running right along the river and under the High Bridge, had by far the largest caves,

forming a labyrinth extending under Cherokee Park. The Joy Avenue segment, now vacated, can still be seen where an unmarked dirt road runs through the woods in Lilydale Regional Park. While most of these caves are very short—root cellars and such—Joy Avenue is anchored by large caves: Mystic Caverns at its eastern end and Echo Cave at its western end. Named after its namesake acoustic effects, Echo Cave served as brick-drying tunnels for the St. Paul Brick Company and was gated as a bat hibernaculum by the DNR in 1989. Beyond that are the brick company's clay pits in the Decorah Shale, a bizarre industrial landscape but the city's premier ice-climbing venue because groundwater seeping from the cliffs freezes to form gigantic ice formations in winter.

The Mushroom Valley caves had been considered for bomb shelters during World War II, well before the Pearl Harbor attack. In the early 1960s, they were surveyed by a local firm, TKDA, for suitability as nuclear fallout shelters, producing the only maps that we have today. Generalizing from the TKDA survey, the typical cave is a straight, horizontal passage about 150 feet long, often connected by cross-cuts to similar caves on either side, creating network mazes with multiple entrances. A cave operated by the Becker Sand & Mushroom Company was the largest of all, with 35-foot ceilings and nearly one mile of passages, its wonderful hybrid name capturing the chief dual usage seen throughout the valley. Perhaps, given this dual usage, it might just as well have been called "Silicon Valley."

The 1962 Civil Defense maps have limited usefulness to the would-be explorer, however, as the surveyors only included passages large enough to accommodate the atom-harassed populace. Crawlways, stoopways and windows into other passages were deliberately omitted, sometimes leaving out half the passages in the cave. Even if too small for human beings to enter, such connections often have a major influence on air flow, the hibernation of bats and so forth.

Not all the former sand mines were used for mushroom growing. Examination of city directories, insurance atlases and real estate plats allowed me to reconstruct a fuller picture of the diversity of people and businesses that inhabited Mushroom Valley. These sources reveal what each of the caves was used for, as it is fairly easy to correlate each street address with a particular cave entrance. In this chapter, I will focus on the three chief uses of the Mushroom Valley caves: mushroom gardening, cheese ripening and as places of entertainment, especially nightclubs. Another major cave-related industry in the valley, brewing, has been described in a previous chapter.

The hopeful comparison made by boosters in the post-mushroom era has been with Kansas City, Missouri, where a subterranean industrial park of several thousand acres, the so-called SubTropolis, was created from a room-and-pillar mine in the Bethany Falls limestone, beginning in the 1930s. Most of the space is used for storage, especially food storage, as Kansas City is a hub of transportation near the geographic center of the United States. But the abandoned limestone mines also hosted manufacturers of precision instruments, one of which made parts for the Apollo moon program. Although this use of underground space is periodically suggested for Mushroom Valley, as it was most notably by the Condor Corporation in the 1980s, inevitably a counter-movement develops, arguing that the neighborhood will be undermined and collapse into the ground.

Mushroom Gardening

The Greeks and Romans were fond of eating mushrooms collected in woods and meadows, but it was not until about 1650, in Paris, that one particular species, the white mushroom (*Agaricus bisporus*), was actually domesticated, or cultivated. Other species had been cultivated in the Orient centuries earlier. The white mushroom thrived on horse manure but not as well on the manure of other animals. About 1800, Parisians found that mushrooms could be grown in the dark, in the subterranean stone quarries that honeycombed their city, which provided even temperature year-round. Mushroom cultivation did not reach the United States until 1865. In the 1880s, there was an abortive attempt by the Mammoth Cave Mushroom Company in Kentucky to raise mushrooms in that cave, the product being served up at the Mammoth Cave Hotel and shipped to eastern cities.

The original mushroom farmers in St. Paul were Frenchmen who "had seen mushrooms growing in the caves under the sewers of Paris." Interviewed on several occasions by Oliver Towne, the St. Paul mushroom farmers stated that their predecessors began the local industry in the 1880s.

In the early days, it was often necessary to abandon a cave after growing mushrooms in it for just a few years due to the accumulation of diseases and insects. About 1890, however, a method for the direct germination of mushroom spores was developed at the Pasteur Institute in France. A pure spawn industry began selling disease-free inoculum, grown in milk bottles, to mushroom farmers.

An article in the *St. Paul Pioneer Press* on May 27, 1923, titled "St. Paul's Caves Eclipse Backlot for Gardening, Except for Crop Foes," by Jay W. Ludden, offers a unique glimpse of mushroom farming in the St. Paul caves. Ludden was clearly awed by the sheer size of St. Paul's mushroom caves: "These caverns have cathedral-like arches, and looking into them through the dusk that conceals details and accentuates the big lines, one is reminded of etchings of the interiors of medieval temples. This impression is strengthened when at the distant end of the cave the workmen's lamps give light as from an altar."

"As with all gardening," Ludden mused, "the more one goes into it, the more one is disillusioned as regards its simplicity. Pests and blights and molds confront one, and remedies are more or less difficult to apply." By 1923, the pure spawn technique had been adopted by local growers: "Spawn culture is a big industry of one St. Paul company, which has had at one time on the racks used for the purpose, 125,000 milk bottles containing spawn."

But Ludden also reported, "Terrific battles are carried on in the dark depths of the caverns, victory going sometimes to the gardeners, and again to the bugs, which, microscopically, are appalling and ferocious." The newspaper article contains an incredible image showing a man, dagger drawn, battling an enormous manure fly inside a cave carpeted with the "ghostly blossoms" of mushrooms. "The artist has depicted a terrific battle between a mushroom grower and one of the enemies that attack his crop," the caption explains.

One of the standard authorities on mushroom pests, published by the U.S. Department of Agriculture in 1941, describes the manure fly as having "a hump-backed appearance. They are quite active, moving about constantly in a series of jerky runs." While there were several control measures, such as light traps, dusts and fumigation, the best strategy was to prevent infestation of beds in the first place. Horse manure compost was placed in the caves and allowed to "pasteurize"—also called "sweating out"—during which the temperature of the compost rose spontaneously to 145 degrees Fahrenheit, which killed or drove off most of the pests. After letting the temperature return to normal, the beds were inoculated with spawn and the mushrooms began to grow. But Ludden reported, "The source of the fertilizer has been noticeably diminishing with the decrease in the number of horses, owing to the rise of motorized transportation."

One of the "crop foes" not found was weeds—at least not those of the photosynthetic variety. "For the weeds grow to a height of only four or five inches," Ludden continued mawkishly, "pale and frail, like the heroines in

"A terrific battle between a mushroom grower and one of the enemies that attack his crop," sketch of a St. Paul mushroom cave, 1923. St. Paul Pioneer Press.

the old time volumes of Select Reading for Young Ladies, then droop and die, like one of those heroines distraught by the idea that her mother suspects her of having told her first untruth."

In addition to their battles against the bugs, Ludden also noted wars among the mushroom farmers themselves. In one nasty case, a mushroom cave was prevented from expanding farther into the sandstone by another mushroom cave that had burrowed completely around it. I recall exploring these two caves years ago and had been puzzled by their arrangement until I read Ludden's report.

Further technological changes after 1923, however, improved the lot of the mushroom farmer. The adoption of the "tray system" in the 1930s, and the consequent disappearance of the old floor beds, was a big step forward in controlling mushroom pests. No longer could the pests seek refuge in the underlying soil during pasteurization, only to later re-infest the beds. Indeed, remains of these wooden trays form the chief diagnostic artifact of former mushroom caves in St. Paul.

A more recent newspaper article, "Mushroom Farming Is Family Tradition," in the *St. Paul Pioneer Press* of March 28, 1976, paints a sad portrait of Mushroom Valley in its final days. "Mushroom growing," one of the farmers pointed out, "remains hard and backbreaking work because some things simply cannot be mechanized—including the picking of mushrooms." Although more than a dozen families once engaged in the work, few members of the younger generation seemed willing to adopt the manure-based lifestyle involved. By contrast, William Lehmann, known locally as the "Mushroom King," had already moved his operation to "the world-renowned cement-block caves of Lake Elmo" in 1965. Presumably the more rural setting at Lake Elmo, east of St. Paul, made for cheaper horse manure than in the heart of the motorized city. And specially designed aboveground facilities, as at Lake Elmo, while initially more expensive than caves, allowed for finer tuning of environmental conditions, including the control of pests and diseases. The last cave ceased production in the 1980s during the creation of Lilydale Regional Park. The Mushroom Century had drawn to a close.

Cheese Ripening

Humans have been using caves to ripen cheese for millennia. The story of the Cyclops's cave, where an early type of the popular Greek feta was ripened, appears in Homer's *Odyssey*. The French Roquefort caves likewise have a history dating back to classical antiquity. In the first century AD, the Roman scholar Pliny the Elder was said to have served this cheese to guests at his villa. The blue, aristocratic veins running through the cheese were partly responsible for Roquefort being called *Le Roi des Fromages*—the King of Cheeses. Italy's Gorgonzola and England's Stilton are similar blue-veined cheeses.

The Villaume Box & Lumber Company, founded in 1882, was a well-known St. Paul business, "one of the nation's leaders in the manufacture of custom millwork, shipping cases and boxes," according to a 1940 promotional brochure. The brochure continued:

> *Villaume has on its own property, 14 hillside caves with surface level entrances. Each cave has a ceiling height of 12 feet and is 20 feet wide. The 14 caves contain a total of 50,000 square feet of floor space, usable for manufacturing, storage, or as shelters in event of air raids.*

From 1933 to the 1950s, the University of Minnesota rented one of the "V Caves," as they were known, and produced a domestic Roquefort cheese—subsequently named Minnesota Blue—an event that would have international repercussions. St. Paul was acclaimed the "Blue Cheese Capital of the World" during World War II.

Professor Willes Barnes Combs, a native of Missouri, was appointed professor of dairy industry at the University of Minnesota in 1925. He soon discovered "a queer local fact. There are dozens of sandstone caves in St. Paul." In the late 1920s, while shopping for mushrooms at a cave in St. Paul, he noticed that a lantern in the cave was covered with rust. The mushroom grower informed him that the atmosphere of the caves was extremely moist. Combs conjectured that the caves might have a combination of temperature and humidity similar to the celebrated Roquefort caves of France, where Roquefort cheese is produced. A crucial problem was keeping the temperature low while maintaining high humidity—an almost paradoxical combination.

Professor Combs met with spectacular success. "Million Yearly Cheese Trade Seen Here," crowed the *St. Paul Pioneer Press* on January 6, 1935,

University of Minnesota Cheese Cave, St. Paul. *National Butter and Cheese Journal,* 1935.

reporting how "the dairy chief," Combs, "disclosed that nearly 10,000 pounds of Roquefort-type cheese, the flavor of which amazed epicures, was cured this year in a small, experimental cave, within a few minutes' walking distance from St. Paul's City Hall." *Popular Science* magazine featured the university's cave in its April 1935 issue under this heading: "Caves for Cheese Making Discovered in America."

The cheese was ripened in the caves for three months, removed, wrapped in tinfoil and placed in cold storage for six months, by which time it had developed "that heavenly stink which goes so well with cold beer." The conditions were rather exacting. "This cock-eyed cheese is very temperamental about its adolescence," wrote one reporter.

Combs claimed that there were enough caves near St. Paul to supply the entire world demand for Roquefort. "There's not a European cheese that can't be made right here in Minnesota," he boasted. Talk like this did not go unnoticed for long. M. Henri Cassou, a member of the French Foreign Trade Commission, swooped down on "the bastard caves," declaring, "There is only one Roquefort cheese and it is made in France." "Genuine Roquefort cheese," Cassou informed the American, "is made from sheep's milk. This milk has other properties, because of the peculiar conditions

of vegetation around Roquefort, France." The Minnesota product, by contrast, was made from the more plentiful cow's milk, which sometimes imparted a yellowish tinge to a cheese that was supposed to be white. France had "an old agreement with the State Department which somehow restrains American cheese-makers from labeling their cheese with the dear old name that sends cheese fans off into the gentle dithers." Combs was obliged to "fall in line with the panty-waists, and just call it 'blue cheese.'" It was eventually named Minnesota Blue.

Having begun with such fanfare, Combs's Roquefort project dropped out of sight until the fall of France to invading German armies in June 1940, which cut off French imports decisively. "City's Million-Dollar Cheese Industry Gets Off with Bang," trumpeted the *Pioneer Press* on December 15, 1940. In the autumn of 1940, the Kraft Cheese Company of Chicago rented "one big cave, 150 feet deep" from Villaume, and its "K-men" began marketing the ROKA brand of blue cheese, while the Land O'Lakes Company—its rival just down the bluff—rented "two caves, 100 feet deep," at the former Castle Royal nightclub, which had gone bankrupt in 1940. In January 1941, the first commercial blue cheese from St. Paul's caves hit the market.

Combs had triumphed. On February 27, 1941, thirty-six Minnesota legislators visited "the University Farm Experimental Cave" (University Cave for short) under Combs's wing and were served blue "as well as some Trappist or Port de Salut-type brick cheese." The legislators went on to visit the Kraft and Land O'Lakes cheese caves, whose very existence owed everything to Combs's mastery of the "dairy arts." As if that were not enough, Combs rolled out yet another cheese about this time, called GOPHER. The University Cave was featured in the *New York Times* on June 18, 1942. One reporter declared that "St. Paul is well on its way to become the blue cheese capital of the world."

By 1945, it was reported that the production of blue cheese ranked second only to cheddar in Minnesota. But concern arose about what would happen to the fledgling blue cheese industry after the war. Fortunately, these fears proved unfounded. In 1949, it was reported that "Imports [of Roquefort] have dropped to practically nothing." The "Land O'Lakes Cheese Cave" was listed at 6 West Channel Street in city directories until 1959.

The last important work carried out in the University Cave appears to have been that of Howard Morris, one of Combs's graduate students, who conducted research there in the late 1940s. A local caver recalls having seen

a derelict sign pointing to the University Cave in the late 1960s. Villaume relocated in 1970, leaving the entire stretch of caves vacant, to the delight of local explorers.

In Faribault, Minnesota, a new cheese plant was established in 1936 to exploit Combs's recipe. Thus originated the Treasure Cave label, now under Canadian ownership. The original sandstone cheese caves go by the name of Caves of Faribault.

The moral of the story is that whereas cave-riddled rocks are usually compared to Swiss cheese, in Minnesota, it was a French cheese that fit the bill.

Felsenkellers

Among the earliest records of artificial caves in Mushroom Valley, *Northwest Magazine*, for November 1886, describes the elaborate caves, called *Felsenkellers* (field cellars) that German immigrants had dug. One of them had "a broad stairway, cut through the sand-stone upwards to the terrace, where the visitor can step forth among the trees into the open air and have from the commanding height, a magnificent view of river and city scenery. The 'Felsenkeller' with its bowling alleys, etc., is occupied by John B. Fandel Jr., whose father spent seven years in fashioning the grotesque interiors of his spacious caverns." The 1891 *Rascher Atlas* labeled Fandell's place a "Cave Saloon." Oliver Towne, too, described "the famous Fandell caves, one of which houses a beer hall called the Mystic Tavern, whose emergency exit was a winding staircase up through 100 feet of rock to the top of the hill above." Unfortunately, those who most needed an exit in 2004 were not able to make use of it (see "Cave Tragedies" on page 79.)

Mystic Caverns

Mushroom Valley's nightclub era began as Prohibition (1919–1934) was winding down. There were two nightclubs here in the 1930s: Mystic Caverns and Castle Royal. A local mushroom grower recalled "the bumper-to-bumper cars that poured past here day and night to those nightclubs." Oliver Towne called Mushroom Valley "one of the oddest night club belts in the world."

History & Lore

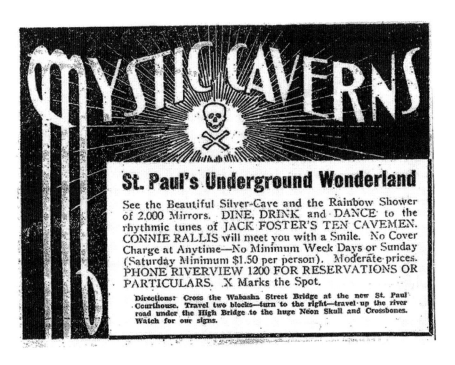

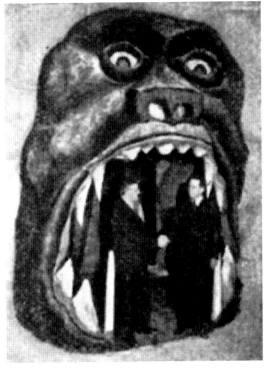

Above: Mystic Caverns advertisement, *St. Paul Daily News*, April 14, 1933. *Author's collection.*

Left: The *King Kong*–themed entrance to Mystic Caverns, "a huge gorilla mouth at the base of a towering sandstone cliff bordering the Mississippi river." Modern Mechanix, *1933*.

Mystic Caverns—not to be confused with Fandell's Mystic Tavern—is forgotten today, but it was beloved in the 1930s. "The most novel café and night club in the country" opened on April 8, 1933, about the same time that the classic version of the movie *King Kong*, starring Fay Wray, hit the movie theaters. Garish newspaper advertisements for Mystic Caverns, with leering skulls, promoted "St. Paul's Underground Wonderland," advising readers to "See the Beautiful Silver Cave and the Rainbow Shower of 2,000 Mirrors. Dine, Drink, and dance to the rhythmic tunes of Jack Foster's Ten Cavemen," spelling out the location exactly: "Cross the Wabasha Street Bridge at the new St. Paul Courthouse. Travel... up the river road under the High Bridge to the huge Neon Skull and Crossbones."

On opening night, four hundred people had to be turned away, and Mystic Caverns was rapidly enlarged so as to hold eight hundred patrons. Revelers entered the nightclub through a large King Kong–head portal in the sandstone bluffs. During construction, liquid glass was sprayed on the walls. There were three main chambers, one of which contained the ballroom, the Silver Cave. According to one patron, the cave contained "a monstrous chandelier, with lights flashing all different colors, two stories above the polished-wood dance floor." The other two chambers held, respectively, the main dining room and "a regular old-time bar, 40 feet long, with brass foot rail and all, where light lunches and beverages will be served." "A system of loud speakers wafts the music from the main dining room into the farthest recesses of the innumerable smaller caverns which serve as private dining rooms," it was reported.

"Entertainment features will be in keeping with the mystic atmosphere, providing palmists, mind readers, psychics and a magician for the amusement of guests." Some of the magical effects were produced by a stage manager for the famous magician Howard Thurston. As if that was not enough, "Ghosts will stalk the river bank, 'living' skeletons will move about its cavernous rooms, weird specters will peer from hidden recesses and women will float above the heads of the orchestra." By far the biggest draw, however, was the nude fan dancer, Sally Rand.

One of the cave's owners, Jack Foster, was the leader of the St. Paul police band, which made it all the more ironic when a Ramsey County grand jury investigation led to the closure of Mystic Caverns in 1934 for running a subterranean casino.

After its brief but meteoric glory days, Mystic Caverns was used for potato storage and in its misunderstood old age was dubbed *Horseshoe Cave*

by the cavers of the 1980s, unaware of its romantic past. In the 1990s, I diligently examined the infinite palimpsest of graffiti on the cave's walls, especially in the former ballroom, hoping for old signatures (or any artifact) from the nightclub era, but could find nothing really convincing. It had been stripped bare, like the fan dancers who had wowed crowds more than half a century earlier.

Castle Royal

The other big 1930s nightclub was Castle Royal, proclaimed "The World's Most Gorgeous Underground Night Club," on South Wabasha Street. Originally a mushroom cave operated by Albert Mouchenott, a French immigrant, it was later acquired by William Lehmann, who achieved local fame as the "Mushroom King." On October 26, 1933, he opened a nightclub in the cave, dubbed Castle Royal, with a fancy patterned brick façade that you can still admire today. Mushrooms, not surprisingly, loomed large on the "dollar menu" that he touted. The chandeliers, fountains and tapestries that graced the establishment came from the recently demolished Gates mansion, as in "Bet a Million" Gates, the largest manufacturer of barbed wire in the nation. The ceiling was stuccoed to prevent the incessant rain of sand grains that would otherwise give you that gritty feel while eating. Doorways were carved out in the shape of mushrooms. In the big band era, performers like Cab Calloway, the Dorsey Brothers, Harry James and the Coronado Orchestra played there. And, of course, there are the gangster stories.

Even before Prohibition, St. Paul allowed gangsters to remain in the city as long as they didn't commit any crimes while in residence—the so-called "O'Connor System." Many were on the lam from Chicago. But crime historian Paul Maccabee, who spent thirteen years researching FBI and police files for his 1995 book, *John Dillinger Slept Here*, which deals with crime and corruption in St. Paul, stated that there was no proof that Dillinger or other gangsters frequented Castle Royal. A 1977 newspaper clipping reports that one of the original musicians "remembers seeing Ma Barker and John Dillinger there, and one of the current kitchen workers claims she witnessed three thugs gunned down at the bar one night back in the 1930's." But the daughter of one of Lehmann's partners wrote, "I must express my feelings about all the sensationalism before the 1977–78

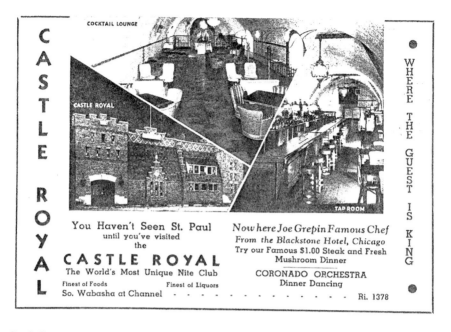

Castle Royal, the second nightclub to open in a cave during the twilight of Prohibition, 1933. *Josie Lehmann Collection, Wabasha Street Caves.*

reopening [of the restaurant]. I never heard of the 'Castle Royal' being a hang-out for gangsters. It would have been most distressing to my father if he had known or suspected such." But given the prevalence of gangsters back in the day, it would also be no great surprise.

The nightclub went bankrupt in 1940, and much of the cave was then rented out to Land O'Lakes as a ripening vault for blue cheese until 1959. After the 1965 Mississippi River flood, Lehmann moved his mushroom-farming operation to Lake Elmo, specializing in pickled mushrooms.

Castle Royal was purchased by Mike Golden and Lebanese restaurateur Jim George, and they refurbished it as a restaurant, opening in 1977. They reportedly invested $500,000 in the venture, injecting an Art Deco motif. The cave had a Bogart-style Casablanca atmosphere, with its sixty-foot bar and dance floor. An aquarium with portholes was suspended from the ceiling, giving new meaning to drink like a fish. Khaki-clad waitresses served up the gourmet fare. Within a year, however, they found that the fancy menu and valet parking weren't selling well in what was dismissively called the "hamburger area" of town, and they reluctantly reoriented the menu toward fast food. Subsequently, a lightning bolt struck the cave, and a patron sued

the owners for an alleged bat bite. A columnist, describing their troubles, labeled it "A Royal Nightmare."

Castle Royal was purchased by Bremer Construction in 1992, which originally planned to use it simply for office space and heavy equipment storage. Under its ownership, the cave flourishes to the present day as the Wabasha Street Caves. The Bremers rent out twelve thousand square feet of finished space for wedding receptions and other events. The cave consists of six parallel passages—some finished, some unfinished and some filled with debris—connected by cross-cuts. The industrious Bremers soon hosted the Great American History Theater and added gangster and ghost tours of St. Paul, a cave tour and a coffee shop. Their success is a shining example of how the caves of Mushroom Valley, rich in history, can be utilized and made profitable again under current economic conditions.

Cave Tragedies

Mushroom Valley has earned a bad reputation in recent decades for the injuries and fatalities that have occurred there, almost as if it were Minnesota's version of Death Valley. But cave accidents are made conspicuous by their very rarity. The annual toll of drownings in St. Paul lakes each year exceeds the total number of deaths in its caves over the past century, yet we never hear anyone talk about forbidding people to swim. Unfortunately, some of the things that were done to the caves years ago have made them less safe than they were before.

The incidents in St. Paul occurred after the caves were left vacant. Broadly speaking, there are two different groups of caves where the incidents occurred, each with a different problem. Along Water Street, where most of the caves are empty, the problem is ceiling collapse, triggered by campfires and loud rock music, whereas along Plato Boulevard, where most of the caves are filled with flammable wood, the problem is usually carbon monoxide poisoning. I will give a few examples of each.

As early as 1954, a "landslide" killed Eddie Brown, a three-year-old boy, during a visit to the abandoned Mystic Caverns, at the west end of Water Street. "Death ended a day of fun....A 60-pound chunk of sandstone fell from above the cave arch…and struck him on the head....Mrs. Brown, who became hysterical, was put under sedatives at the hospital." We learn from a follow-up that Mystic Caverns was the scene of "wild parties by teenagers"

in the 1950s. Then as now, no one could figure out how to seal a cave properly. "It had been boarded up, even blocked off with cement blocks, and still had been broken into, the report said. Police had suggested the cave be dynamited to destroy it."

An increasing number of caves became vacant along Water Street in the late 1970s, especially after Ramsey County bought out the old Altendorfer and Biscliglia mushroom farms. Water Street formed a connection between the Harriet Island and Lilydale segments of a proposed regional park. The first incident occurred on May 26, 1984, when "Cave No. 532" (a designation based on its Water Street address) collapsed, killing one person from skull fracture and paralyzing another with a broken spine. A campfire, lighted to provide warmth in the chilly cave, had dried and weakened the sandstone ceiling. In response, city officials smashed in the roof of the cave, a solution that was effective in this case because the cave was on a slope and there were no buildings above it. On October 20, 1993, two teenagers were critically injured in another cave collapse along Water Street.

Police cars began regular patrols along Water Street, but evading them became just one more thrill for the explorers. A sensationalist element crept into the media's coverage of the area. One newspaper article suggested that bodies dug up in local cemeteries were being carted into the mines by Satanists for unspecified purposes. One caver even began noting "shrines" on his maps of the abandoned mines. It was like a bizarre parody of the "medieval temples" that Ludden had imagined back in 1923.

In 1985, the old High Bridge over the Mississippi River was demolished, and the resulting concrete chunks were shoved into the abandoned caves along Water Street. This was the origin of the bizarre rebar "snake pits" in the caves, with the twisted steel rods projecting outward in all directions. I could tell what cave I was in—Big Snake or Little Snake—from what diameter rebar it contained, one inch or a half inch, respectively. This was another unsuccessful exercise in filling caves, but at least here, the fill material was noncombustible.

On Plato Boulevard it was a different story. The great 1965 flood was a Noachic deluge that permanently altered the landscape. In the wake of the flood, the floodplain was replatted and numerous damaged buildings were razed, the debris being bulldozed into the vacant caves along what is now Plato Boulevard, forming the cursed "wood fill" that plagues us to this day. These caves are so dry and dusty that it's easy to see how a rip-roaring fire could get going. The wood was repeatedly set on fire by trespassers in the

caves, where it smoldered, causing carbon monoxide poisoning, sometimes long after flames were no longer visible and the air seemed clear. Although passersby sometimes reported smoke billowing from cave entrances, firefighters do not usually enter caves to extinguish these fires owing to the risks involved. The antediluvian caves, it seemed, belonged to an idyllic past that was gone forever.

The Peltier Caves, on Plato Boulevard, became notorious after the death of two seventeen-year-old girls there on September 26, 1992, overcome by carbon monoxide that had settled in a low spot in the cave from past fires. City officials initially sealed the caves with heavy machinery. A warning sign was erected outside the cave by the parents, reminding potential explorers about the fate of the two girls, but a dozen years later, on April 27, 2004, three more teenagers, again seventeen years old, walked right past that very sign and died in the neighboring Fandell Caves, also from carbon monoxide poisoning.

5
MINNEAPOLIS CAVES

Three giant caves have been discovered under Minneapolis by workers boring out mill or sewer tunnels in the St. Peter Sandstone bedrock: Chute's, Schieks and Channel Rock. None of the three big Minneapolis caves is easily accessible to the casual explorer like many caves in neighboring St. Paul. Ironically, this means that the title of best-known cave in Minneapolis settles upon the rather smallish ice cave that forms seasonally behind Minnehaha Falls. This ice cave has been depicted on postcards and usually appears in the newspapers at least once each winter, thus generating far more publicity. In another twist, this small ice cave was probably much inferior to the one that likely formed at St. Anthony Falls each winter, before that much larger waterfall was discreetly clothed by an apron constructed by the Corps of Engineers in 1880, in the days before postcards. I finish up this chapter with a perfectly illusory cave on a former island in the Mississippi River.

CHUTE'S CAVE

Minnesota caves made a dramatic debut on the national stage just after the American Civil War. On December 10, 1866, an article titled "Curious Discoveries in Minnesota" appeared in the *New York Herald*. Reuben Nesmith was digging a potato bin in the town of St. Anthony, now part of

Minnehaha Ice Cave, 1909. The "cave" forms under the historic Minnehaha Falls each winter. *Author's collection.*

Minneapolis, when he struck an iron trapdoor, "beneath which a spiral stone staircase led down into the earth." Along with his brother-in-law, Luther Chamberlain, he descended the stairway of 123 steps and they "found themselves in a narrow horizontal passage, dug in the white sand." They entered "a spacious artificial cave, also excavated in this white sand," which became known as Nesmith's Cave. Successive chambers contained relics of a prehistoric civilization, including iron and copper implements, a colossal human figure, hieroglyphics, a stone sarcophagus and a sacrificial altar. When the sarcophagus was opened, a human skeleton was found, the bones of which crumbled to powder.

The very next day, the *Herald* pointed out an inconsistency in the Nesmith story, suspecting it to be a hoax that "a correspondent at St. Anthony" had foisted on them. Indeed, there are close parallels between the Nesmith Cave hoax and details found in *Ancient Monuments of the Mississippi Valley*, a classic work of archaeology published in 1848 by Squier and Davis, two people cited by the *Herald*. In excavating Native American burial mounds, these antiquarians found stone coffins, skeletons that crumbled to powder and

sacrificial altars with calcined bones. Nesmith concludes, as Squier and Davis had done earlier, that "the relics found are not at all aboriginal in character, and may have been the work of a people existing long before even these prairies were the hunting grounds of the Indians."

The *St. Paul Pioneer*, while expressing doubts, reprinted the original *Herald* story verbatim on December 16. On that same day, the *St. Paul Daily Press* published a continuation of the cave story under the title, "The St. Anthony Wonder." The derisive tone of this anonymous piece suggests that the cave story had been pressed into service as another weapon in the ongoing feud between the rival cities, St. Paul and Minneapolis.

Inside Nesmith's Cave, the *Daily Press* article reported, unnamed explorers found a slab of malachite (an ore of copper). When this was raised, another spiral staircase was discovered. This, too, had 123 steps and was constructed of polished marble with banisters of shining brass. "The descent of these steps," the narrator continued, inverting the proper sequence of geologic layers, "took the explorer down through the Mesozoic and Cenozoic formations, and almost below the post-tertiary periods. The hall to which these steps led was of the utmost conceivable grandeur." The ceiling was composed of stalactites that appeared like diamonds, leading the more enthusiastic "to believe that they had at last found a greater than Golconda." The hall was paved with blocks of gold-bearing quartz. Incongruously, the walls were made of peat. Life-sized human figures of stalagmite were "sitting upright upon conveniently arranged settees, and, to all appearance, enjoying themselves." Switching easily from exploration to eschatology, the narrator ends on a sarcastic note. The cave "is supposed to be the place where good St. Antonians go when they die."

Reuben Nesmith, himself, now entered the fray. On December 20, 1866, the *St. Paul Daily Press* printed a letter in which he affirmed the truth of the *New York Herald* report. "The matter has been kept as secret as possible… until the explorations shall have been fully completed." On December 21, however, a letter to the *St. Paul Pioneer* denounced Nesmith and Chamberlain as "myths" and asserted that no such cave existed except in the *Herald* correspondent's "*cavernous* skull." On December 22, the *Daily Press* referred to Nesmith as "the exhumer of this Toltec Herculaneum" and described the "Pickwickian antiquarians" who chased after "the alleged discoveries."

In another letter to the *Daily Press*, on January 1, 1867, Nesmith attempted to furnish plausible evidence for his cave, claiming that it "connects with the cave so long known to the people of St. Anthony, the entrance to which, is under the mineral springs." He invites the public to visit his cave, either by

the "Grand Staircase...or to enter, if they prefer it, the cave at the falls, and to follow up the long passage."

On January 9, 1867, the *Minneapolis Chronicle* ran the most lurid embellishment of the Nesmith Cave hoax yet. Couched in the form of a letter written from Luther Chamberlin (note the spelling change) to a Michigan antiquary. All the stops were pulled this time.

In this version, Nesmith, Chamberlin and the city council armed themselves with Roman candles and descended into the cave where they traversed the now familiar succession of chambers containing marvels. In one of them, "a huge stalagmite has been formed, we called it the tower of St. Anthony. It is a lofty mass two hundred feet in circumference, surrounded from top to bottom with rings of fountain basins." The next chamber was even larger, enough to contain "the whole of our Catholic Church." A rocket was fired, exploding as it struck the immense dome, creating a shower of falling stars with "the roar of a cannonade."

Nesmith led the city council into ever stranger realms. He illuminated "a delicious little cave arched with snowy stalactites," in which there was a table "adorned with goblin knickknacks. It was the boudoir of some gnome or coquettish fairy." The next chamber was groined with gothic arches and paved with "globular stalagmites." "In a corner fountain," Chamberlin wrote, "we found the skeleton head and body of a serpent of uncreditable size." They passed into "another vaulted cathedral" that was flooded with "a strong iron water." Once again, Chamberlin displayed a gift for vivid imagery: "This dark lake lit up by the blaze of a dozen Roman candles, and reflecting the flashing walls of the cavern, would have made a picture for Barnum." A nearby skeleton, eight feet high, caused him to wax philosophical: "Whether he was a lost traveler, an absconding debtor, a suicidal lover, or a wretched murderer seeking concealment from vindictive pursuers, no one can tell."

After eating a snack, "we again renewed our anxious search for something new." They were well rewarded, "finding innumerable natural curiosities, such as fish, snakes, bats, buffaloes' horns, and bones of all descriptions." The cavern extended under the leaking bed of the river, where they heard "the current of the river washing the rock overhead."

"We had now penetrated about five thousand feet in the interior of the earth, and Mr. Nesmith said that the chambers were still innumerable beyond. Our twine having run out, we made a hasty retreat," Chamberlin concluded. He added that Dr. Chute "is now at work digging a tunnel, commencing below the Falls, with a view of tapping the cave."

On January 10, 1867, the *Minneapolis Chronicle* printed a retraction. The editors declared "the so-called St. Anthony Cave" to be a "stupendous hoax" that appeared "during our temporary absence." The *Chronicle* had hitherto "refrained from joining the St. Paul papers in keeping up the joke."

While the Nesmith Cave hoax was exploded locally, it had a longer life farther afield. In the *Minneapolis Tribune* of July 17, 1867, under "Nesmith's Cave" (the first recorded use of that name), it is reported that "a party of ladies and gentlemen from Milwaukee arrived in St. Anthony…to visit the 'Nesmith Cave.'" The writer continued in a sarcastic vein: "The ladies made a becoming toilet to descend into the bowels of the earth, where they were to feast their visions on the works of art and science placed there by that supernatural class of beings who inhabited this globe and region so many, O, so many years ago." Despite "due search and enquiry," the cave could not be located. "What the gentlemen could have said to their ladies on their return to the hotel, cannot be imagined."

Despite the hoax, Nesmith's Cave was based on a real cave that still exists today, Chute's Cave, named after Dr. Chute, and it was to become part of an amusement resort. In the *Minneapolis Tribune* for August 10, 1875, a "New Attraction" is advertised. "Mr. Mannasseh Pettengill has leased the famous Chalybeate Springs" and will "carry out a plan of improvements, which will make it more popular than it was before the war." As depicted on an engraving of the "St. Anthony Falls Mineral Springs," Pettengill's resort included a photographic gallery, observation tower, hotel and bath. Warner's *History of Hennepin County* mentions "a fish pond and a few curiosities of the animal kingdom. The view of the falls with these extraordinary inducements, rewarded the tourist for the fatigue of descending the long stairway to the bed of the river, and the patronage of the swing, boat and restaurant compensated the enterprising owner." Advertisements for Chalybeate Springs appeared in the *Lake Minnetonka Tourist* throughout the summer of 1876. In one advertisement, almost as an afterthought, we are informed that "a few yards below the springs is the entrance to a tunnel, excavated for water power purposes, and extending some two or three hundred feet into the white sand-rock."

In the *Saint Paul and Minneapolis Pioneer-Press and Tribune* for August 26, 1876, there is another advertisement for Chalybeate Springs. The attractions included "ice cream parlors and [a] cigar stand" and "a little building occupied by M. Nowack, as a photograph gallery, where may be found stereoscopic views of that locality." "The band plays at the springs every Saturday evening," it continues, "and with the grounds brilliantly

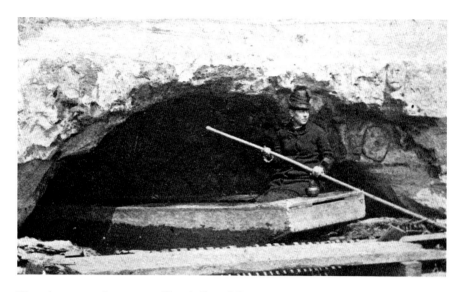

The subterranean boat tour at Chute's Cave, Minneapolis, circa 1875. *Vic Thorstenson.*

illuminated, and the grand old Mississippi rolling and tumbling at your feet, the scene is a beautiful and impressive one." But now we read about "Chute's Cave—A Boat Ride of 2,000 Feet, Under Main Street." This was the first use of the name *Chute's Cave*. The advertisement, an early pitch for what is now called *geotourism*, continues:

> *If you have a desire to* EXPLORE THE BOWELS OF THE EARTH, *Mr. Pettengill can accommodate you in that particular also. The mouth of the "Chute Cave" is just below the springs, and the bottom of this cave is covered with about eighteen inches of water. For the moderate sum of ten cents you can take a seat in a boat, with a flaming torch at the bow, and with a trusty pilot sail up under Main street a distance of 2,000 feet, between walls of pure white sand-stone, and under a limestone arch which forms the roof. It is an inexpensive and decidedly interesting trip to take.*

In the *Saint Paul and Minneapolis Pioneer-Press and Tribune* for December 1, 1889, in an item titled "Underground Minneapolis," we find,

> *Some people, however, think that the only example of these subterranean retreats is the one known as Chute's cave, the mouth of which is in the East side mill district. This most interesting place is no longer frequented*

by human beings of the ordinary sort. But a few years ago not a day passed that did not bring it visitors. A stream of water ran the whole length of the cave, and for the small consideration of a dime a grim, Charon-like individual would undertake to convey, in a rude scow of a boat, all visitors, who were so inclined, for a distance of a quarter of a mile or thereabouts into this gloomy passage. The mouth of the cave was at the foot of a high overhanging bank.

By hosting tours, Chute's Cave became the first and only show cave in Minneapolis.

The summer of 1880 appears to have been the last season for Pettengill's resort, however. In the *Northwestern Miller* for February 18, 1881, we read that a "large force of men is at work on the tail race, which runs along below the Chalybeate springs for several hundred feet, making sad havoc of the fountain and other paraphernalia connected with that resort." City sewers were connected into the tailraces, adding unsavory sights and smells. Pettengill's obituary states that he closed his resort "at a great sacrifice" and opened a farm in Todd County in the fall of 1881. "The beauty of this place [Chalybeate Springs]," it reported, "was ruined by the improvements made for water power and railroad purposes."

But perhaps a more dramatic event also played a role in the demise of Chute's Cave, one that may have suggested to Pettengill or his visitors that the cave was unsafe. On December 23, 1880, Main Street in St. Anthony collapsed.

"Will the History of the Eventful Year, 1869, Be Again Repeated," screamed the *Minneapolis Journal* on December 24, 1880. This was an allusion to the Eastman Tunnel disaster of 1869, which had nearly destroyed St. Anthony Falls, upon whose existence the city's milling industry depended. "A catastrophe occurred on the east side last evening which really threatens imminent danger to the interests of the whole city," it reported. "About six o'clock a noise of cracking timber was heard near H.J.G. Crosswell's flouring mill just below the new Pillsbury A Mill, and immediately after the earth just below the mill settled down about six or eight feet, a portion of Main street going down. The break...extended down the street, between two and three hundred feet, the sink hole being in an oval form." The article fingered the culprit: "The Old Tail Race, Known as Chute's Cave, a Bad Investment," opining, "The Treacherous Sand Stone Under the Lime Rock Does the Business." Warner's *History of Hennepin County* was more succinct: "Into the hole, tumbled a part of Main Street. A tree was swallowed up to the limbs."

Several eight-by-ten glossies of the interior of Chute's Cave and Tunnel, dated October 21, 1936, were apparently taken during documentation of the construction of a sanitary sewer which passes near the cave. They show the square-set timbering that was built to prevent further collapse.

June D. Holmquist wrote about "The Nesmith Cave Mystery" in *American Heritage* magazine in 1951. Interest had been sparked by suggestions that Minneapolis caves could be used as Civil Defense shelters. The August 29, 1950 *Minneapolis Star*, for example, includes Chute's Cave and Tunnel in a list of "atom bomb shelters." More than a decade later, the October 5, 1961 *Minneapolis Tribune* includes them as potential "fallout shelters." But Chute's Cave and Tunnel, with their multiple inputs of water, are unsuitable as shelters from radioactive fallout. As one authority noted, "Water supplies in caves are derived from the surface and are therefore subject to contamination by radioactive fallout." A more fundamental flaw, however, is the location of Chute's Cave. A characteristic of "good mines and caves" is that "they are generally removed from critical target areas," and this cave was located in the nuclear bull's-eye.

That's the last we hear of Chute's Cave for several decades. Today, it can be observed that the cave is situated in the St. Peter Sandstone with a ceiling formed by the overlying Platteville Limestone. While not the largest cave under Minneapolis, the cave is about two hundred feet long and one hundred feet wide and is collapsed in the center. The floor-to-ceiling collapse mound fills the greater part of the cave. Adelbert Russell Moore, engineer for the St. Anthony Falls Water Power Company (which became part of Northern States Power Company in 1923), explored Chute's Cave in 1909, describing the mound as consisting of "fallen lime rock in a very irregular shape, but on the whole somewhat resembling a huge fountain built up in tiers, over which water trickled, the water being impregnated with iron had colored the stone to almost a jet black giving it an extremely beautiful appearance." The water-laid mineral deposits described by Moore are well known to cavers as flowstone, and Moore's mound is assuredly what had been referred to as the "Tower of St. Anthony."

When I first explored Chute's Cave in 1990, the accessible portion consisted of the void space around the perimeter of this enormous mound, and the big room itself. Moore himself called the big room "very wonderful." The triangular chamber, about fifty feet on a side and fifteen feet high, contained a primeval forest of decayed timber, drooping now in the humid gloom, but at one time the beams were meant to hold up the overlying street. I strolled among beautiful crystal formations and

shimmering pools. Giant slabs of limestone, the size of pontoon boats, littered the floor. Some of them were coffin-shaped—the result of the characteristic rhomboidal jointing pattern of the Platteville Limestone layer, from which they had detached themselves. Another slab jutted out into the huge room like a rocky pulpit, or the prow of a ship.

The origin of Chute's Cave has long been obscure. Was it, like other natural caves in the St. Peter Sandstone, created by groundwater washing away sand grains? Or is it artificial, merely a widened segment of Chute's Tunnel? Or is it partly both? The claim that Chute's Cave is a natural cave was made by Moore in 1931 and became the basis for the account presented in Lucille Kane's classic book, *The Falls of St. Anthony*. His assertion is plausible and very neatly explains some aspects of the Nesmith Cave hoax. But state geologist N.H. Winchell, who was quite familiar with the area, having completed a classic study of the post-glacial retreat of St. Anthony Falls, declared that caves are absent from the Mississippi River gorge above Fort Snelling. The jury's still out on that one. But Dr. Jeff Dorale, of the University of Iowa, collected samples of flowstone in the year 2000 from the "Tower of St. Anthony" in Chute's Cave for radiometric dating. This method calculates age based on how much uranium—present in the formation as a trace element—has decayed to thorium. Dorale found that the flowstone post-dates 1880, suggesting that the cave is fairly young.

Chute's Cave continues to live on in the local mythology. Over the years, I have fielded questions about a mysterious cave under Minneapolis where boats float on an underground lake. These are almost certainly garbled recollections of references to the boat rides that were given inside the cave just after the Civil War.

Schieks Cave

An archipelago of sewer caves exists below downtown Minneapolis. In 1939, *Minneapolis Journal* photographer David Dornberg went on a "Camera Safari," as he called it, through these murky caverns. He described it as "a 'lost world,' weird and spooky—the darkest spot for adventure into which my four years as a Journal cameraman ever led me." Some may discount this as sensational tripe, but read the testimony of Roger Kehret, a seasoned Minnesota caver with years of experience, in his 1974 booklet, *Minnesota Caves of History and Legend*: "When cavers think of remote hard to reach caves

it brings to mind scenes of high mountains of the Pacific Northwest or the steaming jungles of the Amazon. The most remote and hard to get to cave that I have ever reached is found on Fourth Street near Marquette Avenue in downtown Minneapolis, Minnesota."

Schieks Cave has also been called Loop Cave, Manhole Cave, or Farmers & Mechanics Bank Cave. It got the name from Schieks Palace Royale, a gentlemen's club that now occupies the Farmers & Mechanics Bank building, under which the cave is located. Journalist Kay Miller once described the nightclub as "topless above, bottomless below" because of the underlying cave, but there's no humanly passable physical connection between them.

Schieks Cave is the largest cave under downtown Minneapolis, extending for a city block through the St. Peter Sandstone, but there are other, smaller caves nearby. Carl J. Illstrup, city sewer engineer, who discovered the cave in 1904, described it as a "cave shaped like an inverted bowl," a description that seems puzzling to anyone who has actually been there. It's shaped more like a pancake that has gone awry on the griddle, if that helps. In 1907, journalist Jack Longnecker penned an atmospheric discovery narrative titled "In Caverns of Eternal Night." In 1931, another journalist, Robert Fitzsimmons, waxed poetical about "the beauties of the sewer system" and described Illstrup as "the ruler of this fantastic world." The discovery of the cave in 1904, during the excavation of the North Minneapolis Tunnel, when the crews braved "the lethal breath of deadly gases," is presented as the high point of Illstrup's life.

The earliest known documentation of Schieks Cave is the 1904 Lund survey, which amply documents the former "creeks" and "lakes" of the cave. Reportedly, the cave was kept a secret for years because city officials feared the public would think downtown Minneapolis was built on a thin shell that would plunge into a hole in the earth. Another concern was that burglars might have worked undetected and bored directly into the bank's treasure vaults. By 1921, it had been reported that "the entire business portion of the city is built over a series of subterranean lakes and caverns as mysterious and baffling as the Mammoth caves of Kentucky or catacombs of Rome." The 1929 Lawton survey depicts the cave extensively modified by the construction of piers, walls and artificial drainage systems. It also shows the seventy-five-foot entrance shaft on Fourth Street, the access point for sewer crews today.

In 1952, the Twin Cities Grotto, the local chapter of the National Speleological Society, visited Schieks Cave, and it was written up for the Sunday supplements. The late David Gebhard, author of architectural guidebooks, was a member of this club. In 1983, a successor club, the

Minnesota Speleological Survey, visited the cave, and their account of the gloomy cave whose walls were black with cockroaches, and the roaring sewer that ran under it, only fired my enthusiasm to get there someday myself.

The earliest published account of someone visiting Schieks Cave without official sanction was by Roger Kehret. In a 1974 story titled "The Minnesota Rovers Great Manhole Cave Expedition," Kehret revealed how the Rovers, an outing club, dressed as sewer workers, surrounded the entrance manhole with barricades and used a truck-mounted winch to remove the heavy hexagonal lid (which in recent years has been welded shut). Getting there must have been more than half the fun, however, because Kehret said little about the cave itself, except that it was "almost filled with sand, concrete, pipes and other debris."

I was able to visit Schieks Cave by hiking through the sewers in the year 2000, a horrific experience I described in my 2009 book *Subterranean Twin Cities*. Although this sandstone cave was extensive, its flat limestone ceiling was rather low, obliging us to go about like apes, balancing on our gloved knuckles as we made our way among the sand dunes with grunts of satisfaction. Large natural sandstone pillars, called "stone islands" on the old real estate plats, formed a maze within the cave. Pyramid-style concrete piers supported the ceiling in many locations. It's the best example of the vaguely Egyptian appearance of deep sewer architecture.

A major arm of Schieks Cave ran under the eleven-story Title Insurance Building, which is heavier than the adjoining four-story Farmers & Mechanics Bank. Consequently, there were more of the pyramidal piers here than in all the rest of the cave combined. This part was flooded with a lake of stagnant, bubbling sewage—the "Black Sea"—which years later mysteriously dried up, leaving a polygonally cracked mudflat covered with a whitish efflorescence, like a dusting of snow.

Inside Schieks Cave there was a concrete chamber that resembled a baseball dugout. The chamber contained a ceiling spring that was dubbed "Little Minnehaha Falls" by sewer workers long ago, and it was labeled as such on Dornberg's 1939 map. Groundwater poured from a bedding plane in the limestone ceiling, forming a curtain of water, and deposited vertically striped black and white, or zebra flowstone, on the walls of the room. The black mineral is probably manganese. In fact, the crown jewel of mineral deposits in Schieks Cave, a jellyfish-shaped formation dubbed the Black Medusa, is made entirely of this mineral.

I took the temperature of Little Minnehaha Falls with a thermometer and found this nymph rather feverish. The groundwater temperature was

Schieks Cave, a "lost world" far below the streets of Minneapolis, 2000. *Author's collection.*

19° Celsius, higher than the expected value of 8° C at this latitude. This thermal anomaly could be the result of heat generated by human activities in a densely urbanized area. Boiler rooms, for example, warm up the surrounding ground.

The origin of Schieks Cave is shrouded in mystery as thick as the shimmering curtains of sewer mist surrounding it. The cave was formed by the mechanical erosion of the soft St. Peter Sandstone by running water, a process known as *piping*. However, one view is "that the cave was formed 10,000 to 15,000 years ago...a relic of the Ice Age." The contrasting theory, based on the testimony of sewer engineer Illstrup, is that the cave "may have been formed by water escaping from an abandoned artesian well and washing the sand into the sewer." The sewer referred to is doubtless the North Minneapolis Tunnel, on which construction began in 1889. My own contribution was the discovery that the "Old Artesian Well," at least as marked on Dornberg's map, does not exist. Nor did it ever exist, because even if it had rusted away completely and the hole had become buried with debris, there would still be a corresponding drill hole through the ceiling,

which there was not. Little Minnehaha Falls, it seemed to me, or something like it, could have provided the source of water.

No swarms of cockroaches were seen during my own visits to Schieks Cave. They had been replaced by the sort of fly-and-worm ecosystem that has been found in other polluted urban caves around the country. The Schieks Cave biota is basically a guanophile (excrement-loving) community, with earthworms covering the floor like spaghetti near the broken sewer lines. Fungus gardens, fed upon by swarms of fungus gnats, in turn supported the spiders in the cave. It's truly a concrete jungle in there!

CHANNEL ROCK CAVERN

The decade of the 1930s was the golden age of sewer caves. The Great Depression spawned a vast sewer project meant to clean up the Mississippi River and put people back to work, but it also led to the discovery of natural sandstone caves. In 1935, for example, the sandhogs, as tunnel laborers were called, struck what remains the largest known cave under Minneapolis. Although the name Channel Rock Cavern was given to it years ago, this name has no historical roots that I am aware of. Many cavers to this day simply call it the 34th Street Cave, as it's located near East 34th Street and West River Road. Most of this cave lies within the St. Peter Sandstone, but its ceiling has migrated upward into the overlying Platteville Limestone. To the sandhogs, the cave was a blessing in disguise because it gave them a convenient place to dump their sand as they continued digging the tunnel. In pre-settlement times, the cave had obviously opened onto the riverbanks and then had slumped shut with material sloughing from the slopes above.

Physically, the cave is a great L-shaped hall, eight hundred feet long, twenty feet high and fifty feet wide. The cave may have formed by similar forces that caused the Eastman Tunnel disaster of 1869, where Mississippi River water had been pirated underground through a subterranean channel and back into the river again below the falls. That could be what happened here, eight to nine thousand years ago, as St. Anthony Falls migrated upstream after the last ice age, but there are other theories.

After the discovery of the great cavern, it was briefly considered for conversion into an underground city park. A new access point for the cave was created, a fifty-two-foot shaft down from West River Road, capped with a hexagonal lid, and just under it, a heavy slab of concrete that required

Channel Rock Cavern, the greatest sewer cave in Minnesota, which had its own railway. *John Lovaas, 2008.*

a winch to remove. The cave was only rarely visited after that, so any visit became newsworthy, as in 1972, when sewer workers discovered "several fake graves" that someone had set up inside the cave, probably in the 1930s. In 1979, WCCO broadcasted the first televised visit to the cave on the *Moore-on-Sunday* show. In 1980, the National Speleological Society held its annual convention in the Twin Cities, and this cave was one of the featured stops, again generating newspaper publicity. There were several trips in the 1990s for the benefit of visiting Canadian researchers, allowing them to collect samples of flowstone that had grown over the timberwork inside the cave for the purpose of dating it. But any visit was a big production because the road had to be blocked off temporarily so the lid could be safely removed.

Toward the end of the cave, there's a steep declivity, like the edge of a great sand dune. It did not occur to us until this point that the sand we had been walking on all along was fill material left by the sandhogs as they excavated the sewer in the 1930s. They must have run their tracks ever farther out toward the end of the cave as the latter progressively filled up. In one place, we found the corroded remnants of their narrow-gauge railroad, complete with steel rails and wooden cross-ties. So the cave was much roomier at one time than it is even today. It is almost certain that the fill has buried side passages, which we would like to have explored. We would especially like to have found a connection between the cave and the giant sinkhole in nearby Seven Oaks Oval Park.

At the very end of the cave, down at the bottom of the sand hill, at the very lowest point, there was a sapphire pool of cold, clear water. In earlier published accounts this was called "a small pool of greenish water," the word "greenish" suggesting contamination, but this pool appeared so clean you could drink from it, though the experiment was not attempted. The water derived from seepage through the ceiling, which left hundreds of flexible mud stalactites several inches long, another unique formation for this cave that I hadn't seen elsewhere. I found no amphipods (freshwater shrimp) or other creatures in this pool, again because there were no inputs of organic matter to sustain them. It was like staring into the limpid blue eye of a cyclops inhabiting the cave.

Spirit Island Cave

I finish with an illusory Minneapolis cave. As noted in the journals of the early explorers, there were originally a half-dozen sliver-shaped islands at St.

Anthony Falls, the largest waterfall along the entire course of the Mississippi River. There were islands above and below the falls and some that straddled it. And some of the islands were reputed to harbor caves. The most famous case, clearly a hoax, was the fictitious gold cave of Spirit Island.

Spirit Island, below the waterfall, owes its name to the legend of Dark Day, who deliberately plunged over the falls in a canoe with her child to spite a two-timing husband. Her spirit haunted the island and was sometimes glimpsed in the mist of the falls. For many years, the island's trees were a favored resort of eagles, which would snatch fish that had been stunned by their plunge over the falls—a sort of natural roadkill along the waterways.

By the 1860s, newspapers reported a gold cave on Spirit Island. I've always thought that someone could easily have gotten the idea for this hoax from observing the shadowy, zigzag outcrops, characteristic of the Platteville Limestone, which often appear from a distance to be cave entrances. Sadly, this scenic island was quarried for its limestone in the late 1890s, which ruined the whole place. One old photo of the island from this time reminds me of images of the foundering *Titanic*. The remainder of the island, a mere sandstone stump, was completely grubbed out during the Upper Harbor Project after World War II, which extended the head of Mississippi navigation to above the falls. No gold was ever found, but a huge amount of gold was certainly expended in removal of the island itself.

6
SOUTHERN SHOW CAVES

Show caves, also known as tourist caves, have existed in Europe for centuries. In the United States, the famous Mammoth Cave of Kentucky was an early show cave, with tours starting in 1816. Until recently, it was assumed that no Minnesota show caves predated the twentieth century. My own research revealed, however, that Minnesota had two of the earliest show caves in the Midwest—Fountain Cave and Chute's Cave, described earlier. Both were located in an urban area, explaining how they were able to exist so much earlier than the state's rural show caves, which had to await development of the automobile, and also why their existence was short: loss of scenic values due to encroaching urbanization.

Some overlap exists between caves used for nightclub entertainment and show caves. Basically, a show cave is one you pay money to tour, and thus it is also called a commercial cave. But the term *commercial* is ambiguous, as it could also include caves that are used for commercial storage.

The National Caves Association (NCA), which describes itself as "a nonprofit organization of publicly and privately owned show caves," defines show caves on its website (www.cavern.com) as "caves developed for public visitation." Gunn's *Encyclopedia of Caves and Karst Science*, on the other hand, under the entry "Tourist Caves," states, "Tourist caves can be simply defined as those displayed to the general public in return for a fee or other financial consideration."

Gary K. Soule, one of America's preeminent show cave historians, presented to the author yet another viewpoint, which suggests the complexities behind any definition:

It is important to define what constitutes a true "show cave." A show cave can be classified as a cave where payment is made for entry, but as organized, paid instruction during "wild" trips increases this criterion becomes blurred. At least one site in the U.S. is free, but has walkways, a shop, lighting, and guides. Clearly, this definition is not completely acceptable.... While many factors must be taken into account and there are many borderline cases, the main criterion is whether the cave has more or less fixed hours of operation that are advertised.

According to geographer Kevin Patrick (2013), professor at Indiana University of Pennsylvania:

Although the increased availability of electric lights helps to explain the expansion, the most important factor was the popular adoption of reliable automobiles and widespread building of all-weather highways. With nature rather than economics dictating the location of caves, transportation—whether trails, rails, or roads—has always been critical to their commercial development. More than any other mode, the automobile brought an unprecedented number of potential customers into cave country, fundamentally altering how show caves were interpreted, marketed, and presented to the paying public.

Neuton's Cave, Pine Island, Minnesota. *Author's collection.*

History & Lore

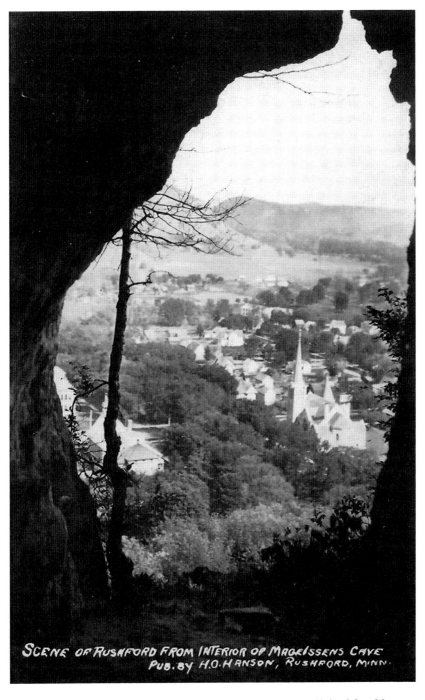

Magelssen's Cave overlooking the town of Rushford, Minnesota. *National Cave Museum, Diamond Caverns, Park City, Kentucky.*

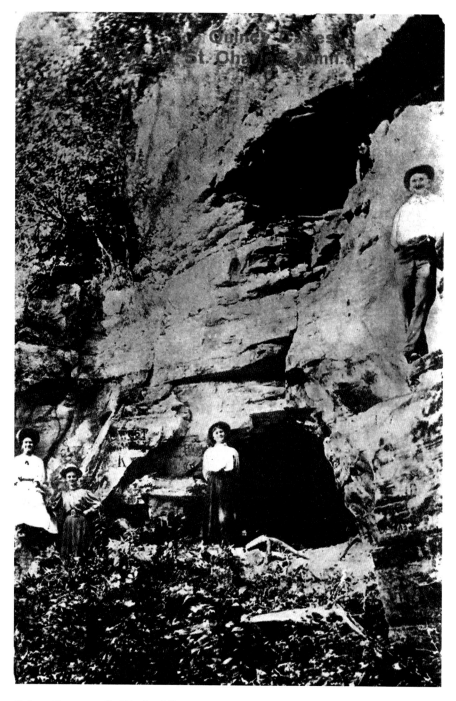

Quincy Caves near St. Charles, Minnesota, 1914. *National Cave Museum, Diamond Caverns, Park City, Kentucky.*

The present chapter describes the belt of show caves running across southern Minnesota, almost like a money belt of sorts, with Fillmore County forming the square buckle. Under the broadest definition, it's likely that there were more show caves than we realize in the early days of Minnesota, but painstaking historical detective work will be required to identify them. I myself have spent many hours digging up former suspected show caves, like the Lake City Cave—a sort of archaeology of geotourism.

Mystery Cave

Mystery Cave was first conceived in the mind of state geologist N.H. Winchell in 1876, based on where water entered the ground and where it came back out again at springs. But in the days before organized caving clubs after World War II, such startlingly obvious cues were not often followed up on. It was left to the gravedigger Joe Petty to stumble across the cave quite by accident more than sixty years later, in February 1937, when he saw vapor coming out of the hillside on a cold winter day. There are no legends associated with the cave, nor are there any prehistoric artifacts found within the cave, contrasting with the nearby, but much smaller, Petrified Indian Cave, described earlier, suggesting that Petty's find was truly original.

Since 1918, there had been a picnic ground at Mystery Cave Park, on the South Branch of the Root River, in what is now Forestville State Park, south of Wykoff, Minnesota. The namesake cave featured a ceiling spring, and a rock basin was built to catch the water, which was piped out to the picnic grounds. But the much longer cave lurked nearby, undiscovered for years. Once the longer cave was discovered, the name *Mystery Cave* was transferred to it from the first one, which then became Old Mystery Cave, nowadays a bustling raccoon den whose occupants were only too happy to take over the spring basin.

Mystery Cave is the longest known natural limestone cave in Minnesota and was the first to show the pattern of phased human discovery, afterward seen at Spring Valley Caverns (see page 109). Thus we have Mystery I, II and III. Not surprisingly, the cave, with its twelve miles of passages, became the focus of an early cave club, the Minnesota Speleological Survey (MSS).

Mystery I, the original discovery, where owner Clarence Prohaska began tours in 1947, has passages in the Dubuque layer of the Galena Group. It features Cathedral Domes, Turquoise Lake and the Bomb Shelter, among

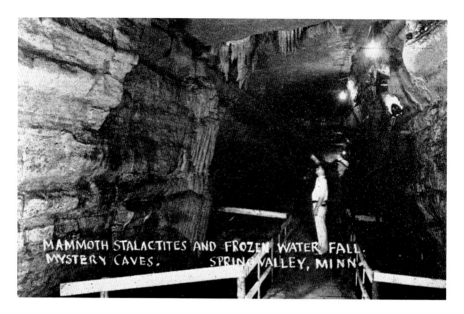

Mystery Cave, the longest cave in Minnesota, showing off its decorations in the days before even greater decorations were discovered deeper in the cave. *Author's collection.*

Rock Garden, Mystery Cave. *Author's collection.*

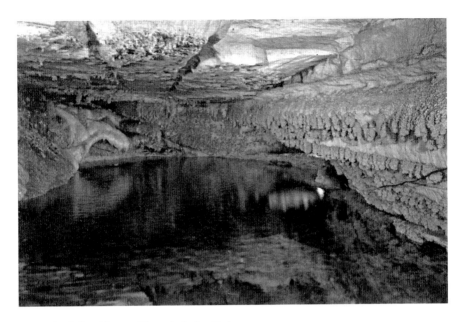

Turquoise Lake, Mystery Cave. *Author's collection.*

other named features. Mystery II was discovered in 1958 during the longest marathon trip inside a Minnesota cave, which lasted eighty-four hours. During that trip, a new exit to the surface was dug at what is now the Mystery II entrance. Tours began at this second entrance to the system under the moniker Minnesota Caverns, in 1960, following passages in the Stewartville layer of the Galena Group. Fourth and Fifth Avenues and Garden of the Gods—a creamy rich welter of flowstone—are highlighted on these tours. Mystery I and II are connected by passages, called the Door-to-Door Route, which would not be welcome to the casual visitor but are a delight to cavers themselves. In 1967, Mystery III was discovered, with its Dragon's Jaw Lake and Eureka passage. In 1988, Mystery Cave was acquired by the Department of Natural Resources and its old tour routes refurbished. So this cave is unusual in undergoing a transition from private to public ownership.

Mystery Cave is a network maze developed along several sets of intersecting joints in the Galena limestone. The rock joints run northwest to southeast and east and west, with a third, minor set at an angle to these. While these three joint directions are ubiquitous in the karst of southeastern Minnesota, they are enlarged into twelve miles of traversable cave passages only in this particular location because the South Branch of the Root River takes a shortcut across a surface river meander, selectively dissolving out

some of the joints to greater size, before reemerging at Seven Springs. The river can be followed for some distance in the lower levels of the cave. In the big picture, however, Minnesota's network caves are not the norm, being outnumbered by branchwork pattern caves on a worldwide basis.

Scientifically speaking, Mystery Cave has been the focus of more scientific studies than other Minnesota caves. This is where the first really detailed Minnesota cave sediment studies took place. From radiometric dating of flowstone, we know the cave is more than 160,000 years old—since before the latest glacial advance. Being near the margins of the continental ice sheet, glacial sands and gravels were washed into the cave, as seen best at Enigma Pit. A detailed biological survey of the cave was conducted in 1993, but nothing especially rare, like blind white fish, was found. The cave is a bat hibernaculum where winter bat counts are periodically conducted and a federally protected bat species has been identified.

NIAGARA CAVE

The 1924 discovery of Niagara Cave, on the Minnesota-Iowa border near the town of Harmony, has a familiar structure—the lost animal narrative. Three boys found the cave while in pursuit of three pigs that had fallen into a sinkhole leading to the cave. In 1932, three investors, Leo, Joe and Al, established the commercial tour, which has become the longest continuously privately operated show cave in Minnesota history. The tour leads the visitor down a long flight of steps, past the sixty-foot waterfall for which the cave is named. The name Niagara has historically been associated with weddings, which entitles this cave, with its Crystal Chapel, to be the most dramatic venue for cave weddings in Minnesota.

Niagara Cave, whose main passageway has a length of 1,750 feet, seems rather short, but it compensates with the greatest vertical relief of any Minnesota cave—150 feet. The passage zigzags along rock joints through the Grand Canyon with its lofty ceiling, ending up at the Stalactite Room at the lower end of the cave. The cave is a stream passage in the Stewartville dolomite, which is especially cherty in this location. The hard chert swirled around, carving out potholes, and the fusion of multiple potholes gives rise to the various named rooms in the cave. The stream has cut down into the underlying Prosser limestone, which is especially soluble, giving rise to the only speleothem-rich part of the cave, the Stalactite Room. The water

History & Lore

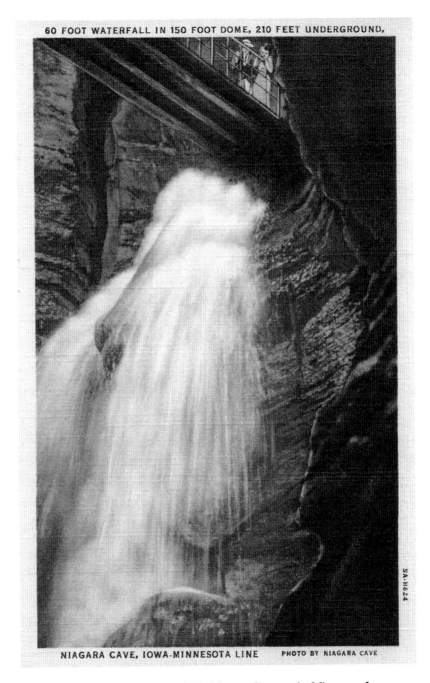

The namesake subterranean waterfall in Niagara Cave on the Minnesota-Iowa border. *Author's collection.*

MINNESOTA CAVES

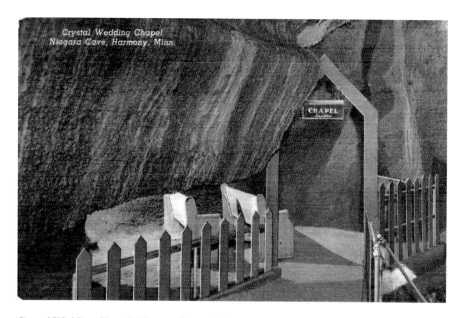

Crystal Wedding Chapel, Niagara Cave. *Author's collection.*

The subterranean river in Niagara Cave, 1934. *Author's collection.*

thereafter flows two miles underground through inaccessible crevices before spilling into the Upper Iowa River at Niagara Spring.

In the bad old days, it was common practice for lazy guides to go down to the Stalactite Room and fling the burned-out light bulbs into the stream sump, where they would bob around for ages. Beyond this sump, cavers clad in wetsuits dug mightily for years to find more passages. They even built narrow-gauge wooden trackways to haul off the sediment—trackways that floated away each time the cave flooded. Sediments were redeposited by the waning waters, pretty much in the same place—labor worthy of a muddy Sisyphus.

As compared with Mystery Cave, which has many passages off-limits to the casual tourist, most of Niagara Cave is visible during the tours. Accordingly, these two great caves provide a contrast in how cave features are named. Many of the caver-supplied names found off the tourist routes in Mystery Cave relate to earth materials (mud, sand), the types of movements required to traverse cave passages (crawls, straddles) or stages of exploration (base camp, discovery route). By contrast, most of the names in Niagara Cave are aimed squarely at tourists, as indeed they are along the avowedly commercial routes in Mystery Cave.

Scientifically speaking, Niagara Cave was described by University of Chicago geologist J Harlen Bretz in 1938 and incorporated into his grand theory of landscape evolution in the days before Mystery Cave became the center of speleological attention in Minnesota. And Niagara Cave was considered interesting enough to have inspired the formation of its own cave club: the Niagara Cavers. While now extinct, this club applied a whole separate nomenclature to Minnesota caves than that used by the current caving clubs. And before the Niagara Cavers, there was yet another whole set of names for Minnesota caves, as I found by researching old newspapers on microfilm.

Spring Valley Caverns

Spring Valley Caverns is perhaps the best example among Minnesota caves of what persistent weekend caving by organized cavers can accomplish in expanding a cave that was declared played out by bystanders. The cave jumped from half a mile to five and a half miles of known passages within several years.

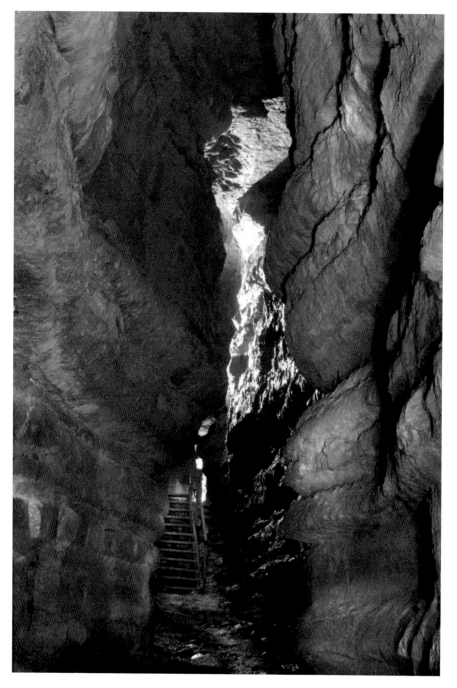

The Grand Canyon, a fifty-foot-high passage in Spring Valley Caverns. *John Ackerman.*

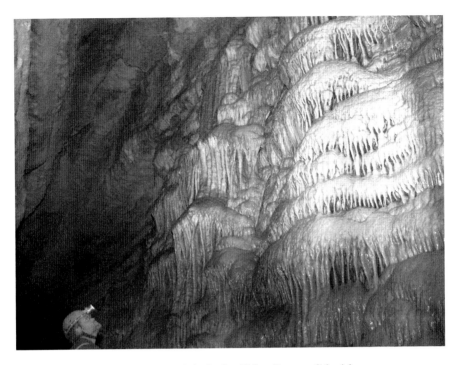

The Frozen Falls, a flowstone cascade in Spring Valley Caverns. *John Ackerman.*

John Latcham found Spring Valley Caverns in the narrow ridge of Galena limestone separating Bear and Deer Creeks just north of the town of Spring Valley, Minnesota, in 1966, while searching for a lost calf. But according to neighbors, it had been known locally before then. Called Latcham's Cave, it was developed as a show cave, operating for two seasons (1968–69), under the name International Caverns and then Spring Valley Caverns. The Frozen Falls (a flowstone cascade on the cave walls) and the Medusa (a jellyfish-shaped formation) are two noteworthy features advertised in early brochures for the cave. But the cave was too far off major highways, and the property was eventually foreclosed upon. It sat vacant for decades thereafter.

The original Quonset hut over the sinkhole, whose floor had collapsed, was replaced by a sturdy stone building by caver John Ackerman, who acquired the property in 1989. Starting from the original tourist nucleus with a half mile of known passages, Ackerman pushed every lead in the cave by following wind and water with "Houdini-type tricks" and judicious application of explosives. I should know, as I helped to wire some of the charges, often while suspended precariously over some frightful gulf. The discoveries fit the

Tyson Spring Cave, a popular picnic spot near Chatfield, Minnesota, where saber-toothed cat bones were found in 2008. *National Cave Museum, Diamond Caverns, Park City, KY.*

pulsed paradigm, in five episodes, leading to the designations Spring Valley Caverns I through V for various portions of the cave. Ackerman installed culverts with ladders into man-made entry shafts that lead into the cave for the ease of accessing distant parts of the cave system. The cave is the usual Minnesota network maze on the prevailing intersecting joint pattern.

Spring Valley Caverns is now the show piece of Ackerman's Cave Farm. Ackerman harvested a crop of three dozen caves on this land over the decades, often using a trackhoe. The Cave Farm in turn is part of his Minnesota Cave Preserve, which includes caves scattered across Fillmore County.

One of these other caves is Tyson Spring Cave, captured in stereopticon views and postcards from the early days, when it was a popular picnic spot. Spring water gushes from the entrance at fifty gallons per minute at the base of a 120-foot cliff of the Galena limestone. A commercialization attempt was made in the 1930s, but the cave was not thoroughly explored until the Argonaut Society and others came along with scuba gear in the 1970s, allowing explorers to get past the sump, or water-filled passages, to more walking passages beyond. Some of the ledges in the passages were lined with frogs, staring blankly at the determined explorers as they marched past. Ackerman installed a culvert to allow dry access beyond the sump to the estimated three miles of passages in this branchwork cave.

Most amazing of all were the saber-toothed cat bones found in Tyson Spring Cave in 2008. A paleontologist from the Illinois State Museum, Chris Widga, reported a radiocarbon age of 22,250 years for the bones, at which time the cat lived in a steppe-tundra environment and perhaps preyed on ice age mammoths. This is surprising when you realize that the saber-toothed cat deposit most people are familiar with is the famous La Brea tar pits of Los Angeles. It's enough to validate the 1867 quote by Luther Chamberlin that began this book.

CATACOMBS OF YUCATAN

The Reverend Horace Carter Hovey (1833–1914), considered by many "the Father of American Speleology," whose book *Celebrated American Caverns* initially got me interested in cave exploration years ago, wrote intriguingly of "caves that exhale music and sunshine." I would have to say that the Catacombs of Yucatan came nearest to fulfilling that promise for Minnesota.

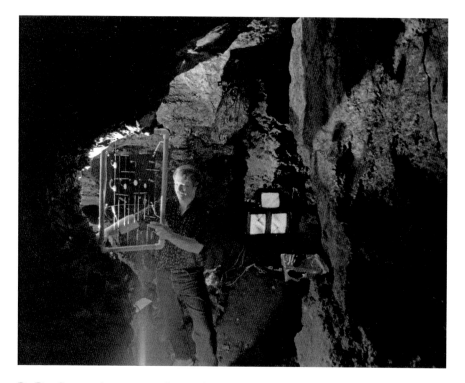

Dr. Dan Senn setting up a sound art and video installation in the Catacombs of Yucatan, 1995. *Dr. Dan Senn.*

The commercialization of this cave is a Great Depression story, a hilltop beacon in the dusty gloom. Noted as early as 1880, this cave in the Yucatan Valley at Black Hammer, Minnesota, was found to contain skeletons, assumed to be Indians, hence its name. The cave is short and simple, looking like a wishbone on a map, so it certainly did not qualify as a catacomb in terms of complexity. Its 272 feet of passages wind through the Oneota dolomite caprock of the bluff. The cave, on private land, can be reached after an exhausting climb up the steep, sunny hillside, picking your way carefully so as to avoid rattlesnakes.

The Catacombs of Yucatan was commercialized for tours in 1934. A dance hall was constructed next to the cave, and its lights, seen from afar, were an inspiration. In 1995, composer Dr. Dan Senn reprised a bit of this magic with a "Sound & Video Installation," the remains of which were still visible years later when I visited the cave after a long absence and made inquiries about these interesting relics. Exotic musical instruments such as the Winged Pendulyre were installed by this latter-day Orpheus, where

formerly only flutter of bats' wings could be heard. He recorded valuable oral history on the cave, detailing the hard lives and deaths of people during this dusty era.

According to Dr. Senn,

> *The Catacombs of Yucatan is a name for a limestone cave and dance hall which had been commercialized in 1934 in the hills separating Houston and Spring Grove; a venture which succumbed to hard times after several intense years. By the time I arrived in mid-August 1995, local memories had become vague, along with the access road which had once passed within 50 feet of the cave. I had spent many summers in the area since childhood [1950s] and knew a little about Catacombs lore. Now, with a McKnight Visiting Artist grant from the Minnesota Composers Forum, I was returning to dispersed memories, cave bats, cow manure, and an electricity-free cavern located a half-mile from the nearest gravel road.*
>
> *The enterprise went broke, and the Depression hurried this along. The cabins, used for overnight stays, were sold off for nonpayment. When I did the installation in 1995, the road that ran close to the site in the 1930s was gone, but it had been dirt, not gravel, and getting up the hill in rain would have been difficult. Stories about that. The cave isn't so spectacular to draw people from afar and so it really just attracted locals who were so greatly impacted by the depression. My father, born in 1920, was forced to leave home at 12 and work so that he could go to school in Houston. They were all dependent on FDR work programs. I doubt that much money was made on the enterprise. It all had to be electrified too.*

HIAWATHA CAVERNS

The name *Hiawatha* is a treasured tourist commodity in southeastern Minnesota that has even been bestowed on landscape features such as valleys. So what could be more natural than to give a show cave that name? "Visit Hiawatha Caverns, King of all the underground and father of all caves," ran the boast.

Hiawatha Caverns was discovered near Witoka, Minnesota, in 1962 and commercialized for three summers (1964–66) with the novelty of all female guides. The story that spread later was that the lazy owners had tricked the locals into removing many tons of rock and soil for free and then ran a half-

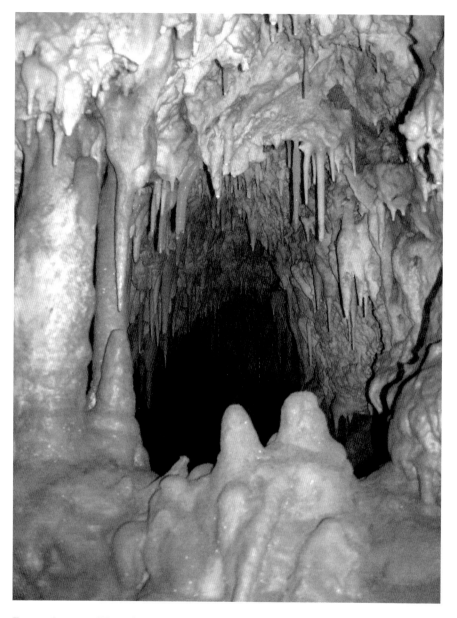

Former show cave Hiawatha Caverns abounded in the "stumps and spikes" beloved of tourists, Witoka, Minnesota. *Javier Guzman, 2007.*

hearted business which, when it proved unprofitable, led them to abscond in the middle of the night, leaving behind debts in the community. The next manager did the same thing. The cave never reopened for business, but the derelict tool shed that doubled as the ticket booth still stands. Although the cave is located in proximity to Interstate 90, the nearest exit from that highway is annoyingly far away.

A steel door on a hillside opens into a concrete tunnel and then a succession of fairy grottoes. During a trip to Hiawatha Caverns in 2007, I was impressed by the wide variety of colorful formations (the proverbial "stumps and spikes") still existing in this twisting eight-hundred-foot maze. It's the only significant show cave developed in the Oneota dolomite in Minnesota.

This cave is not to be confused with its rival Hiawatha Caverns in neighboring Wabasha County, which was never opened to the public, despite extensive preparations for commercialization. During visits to this cave, I recall crawling through trenches dug in the floors, resembling a World War I battlefield in miniature—a battle to be played out among warring show caves, vying for the tourist dollar. But this cave has a much longer history than its rival, stretching back to 1856, when it was discovered during a fox hunt. You will indeed find that much southern Minnesota cave history begins just after the Treaty of Traverse des Sioux (1851) opened the land for European settlement.

Seven Caves

While Jesse James and his gang robbed banks, others made a living off their exploits, taking the money right back to the bank. Along Highway 169 south of St. Peter, Minnesota, several holes in the sandstone outcrops alongside the highway were visible years ago. Although the caves are artificial, according to some sources, they were merely enlarged from natural caves formed by groundwater flowing through the Jordan Sandstone. In any case, they are the only remnants of a much larger cave system developed by Charlie Meyer, who bought the property back in 1930.

Working in the Kasota stone quarries across the Minnesota River, Meyer was an expert sculptor. He lovingly took the time to carve elaborate historical figures and painted them, creating a nice show cave that he called Seven Caves, or Jesse James Cave. The signature theme was that the cave was used

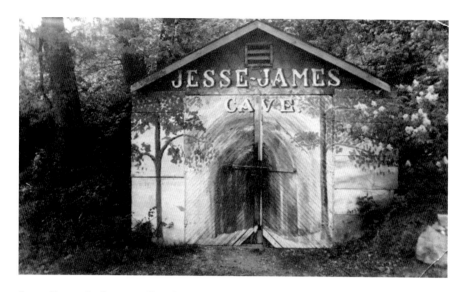

Seven Caves, also known as Jesse James Cave, once famous for its sandstone sculptures of the notorious gang, St. Peter, Minnesota, 1942. *Nicollet County Historical Society.*

as a hideout by Jesse James on his way to robbing the Northfield Bank in 1876. Although these stories had circulated for years, a surviving member of the gang later denied the use of caves for this purpose, pointing out that caves just as easily became traps for those pursued.

As usual for sandstone caves, with their lack of natural ornamentation such as stalactites and stalagmites found in limestone caves, something had to be done in the way of artificial embellishment to compensate. Whether the gang had used the cave or not, Meyer commemorated each member with a carved head in the wall. But Meyer's life work was wiped out when Highway 169 came through in 1954, destroying four of the original seven caves. Exploring the remainder myself years later, I could find no trace of his handiwork.

Whether or not Seven Caves afforded refuge to the Jesse James gang, they certainly afforded refuge to hibernating bats. During the great Armistice Day blizzard of 1941, many bats could not relocate the cave entrances, which had drifted shut with snow, and perished miserably outside. But it was a good day for the local cats, who carried away the frozen bat carcasses.

STILLWATER CAVES

According to local legend, French trader Jules St. Pierre opened a trading post at the location of a spring in the Jordan Sandstone bluff in what is now Stillwater, Minnesota, in 1838. By 1868, a Swiss brewer named Joseph Wolf was hollowing out a space around the spring, enlarging it to form a natural refrigerator for the beer he was brewing. But the brewery shut down during Prohibition and the cave sat vacant for decades.

In 1945, local entrepreneur Tom Curtis purchased the vacant cave, enlarging it, adding a trout pond fed by the natural spring water and a boat tour through a canal system, which opened in 1958, running till 1973. This attraction, at first called Curtis Caves, then Stillwater Caves, signaled the transition of Stillwater from an industrial town, based on sawmilling, to the tourist destination it is today. During the Cold War, the cave doubled as a fallout shelter and was stocked with Civil Defense supplies. This became the only Minnesota cave where actual Cold War ceremonies were enacted, with schoolkids being marched into caves. The Cold War mascot "Bert the Turtle," famous for his admonition to "Duck and Cover," had now acquired a rocky carapace.

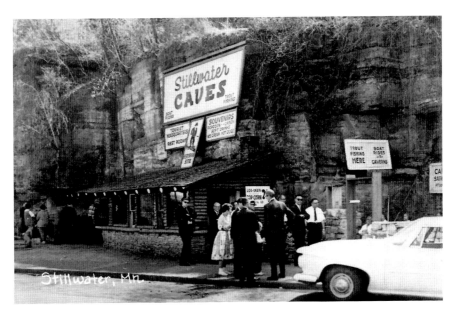

Stillwater Caves, early 1960s, served as a Civil Defense shelter during the Cold War. *National Cave Museum, Diamond Caverns, Park City, Kentucky.*

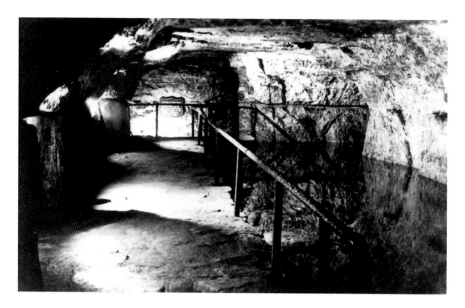

Stillwater Caves, also known as Curtis Caves, showing the canal system on which tourist boats floated, inspiring comparisons to Venice. *Author's collection.*

Under the name *Blue Grotto*, recalling the famous Blue Grotto on the Isle of Capri, the cave served as a mood piece for an adjacent restaurant. At other times, keeping with the Italian theme, the Venetian canals inside the cave were emphasized. The cave itself was intermittently reopened for tours after Tom Curtis sold the operation, most recently as the Joseph Wolf Brewery Cave, when it was elaborately decorated for Halloween.

7
NORTHERN CAVES

Caves are far fewer in northern Minnesota owing to the geological formations there, which are less favorable to cave development. Whereas southeastern Minnesota is underlain by water-soluble Paleozoic sedimentary rock such as limestones, and loosely consolidated sandstones, the northeastern part offers stern igneous-metamorphic terrain of Precambrian age. The warmer climate in the south also helps to accentuate cave development.

ROBINSON'S ICE CAVE

As defined by Alpine scientists in Europe, ice caves contain perennial (year-round) ice. In Minnesota, with its modest elevations and mid-latitude position, such conditions do not exist, and only seasonal ice can be found in our version of an ice cave. This precludes the notion that the ice in such caves is a relic of the last ice age, as well as expecting to extract a long-term paleoclimate record from the ice, as has been done elsewhere.

Robinson's Ice Cave is Minnesota's closest approach to a true ice cave. A towering cave opening, sealed with a ladder-like gate to keep people out but allowing the bats to enter, presents itself in Banning State Park, near Sandstone, Minnesota. Following a fracture in the Precambrian Hinckley Quartzite for a distance of two hundred feet, this cave serves as a DNR-

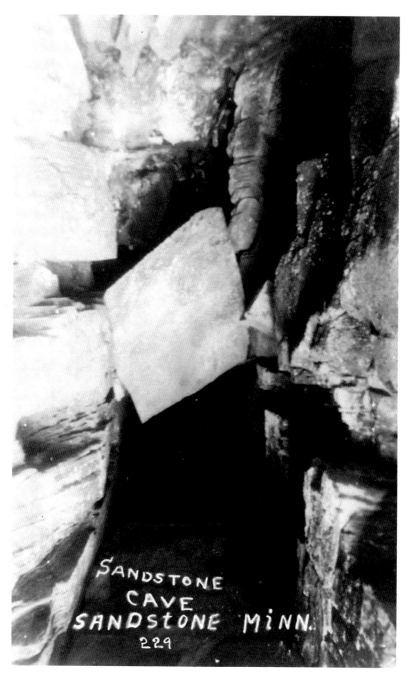

Robinson's Ice Cave, a rare mid-latitude ice cave and bat hibernaculum at Sandstone, Minnesota. *National Cave Museum, Diamond Caverns, Park City, Kentucky.*

protected bat hibernaculum. A large chockstone boulder, wedged where it fell, overhangs the passage. Captured on an early postcard, the boulder remains in the same position today. Legend has it that the cave extends under the Kettle River.

There are two kinds of cave ice: nivation ice and regelation ice. Nivation ice forms by snow blowing into a cave entrance and morphing into ice layers. Regelation ice forms by spring meltwater dripping into a cave and refreezing in the cold air trap created by the cave. The ice in Robinson's Ice Cave is strictly the latter kind. In the spring of each year, club-shaped ice stalagmites, some as tall as a person, grow up from the floor. Hardly comparable to the elephantine ice formations of European caves, but it's what we have.

North Shore Caves

The relentless pounding of the waves of Lake Superior against Minnesota's North Shore has gnawed at rock joints that are suitably oriented, carving out caves, especially in Lake County. Sometimes they are called "sea caves," but on a freshwater lake that phrase seems rather odd, so they are referred to as littoral (shoreline) caves by geologists. Strangely, no relict littoral caves from the much higher post-glacial shorelines of Lake Superior have been found. All the known caves formed at present-day lake levels.

Certainly the best known cave along the North Shore is the Cave of the Waves, featured on postcards. Formed in a rocky promontory of rhyolite forming one side of Crystal Bay in Tettegouche State Park, near the town of Silver Bay, Minnesota, the cave is one hundred feet long and elbow-shaped in map view. The cave is most often visited by kayakers, but it can also be reached by wading out from shore if you have a wetsuit, as I was able to do one fine day when the lake surface was especially calm. Standing inside the watery cave, I had my own private vista of Lake Superior.

The Thunder Caves at the mouth of the Manitou River are nearly as well known, also being depicted on postcards. Once a tourist attraction, the caves are now private. Other easily accessed shoreline caves include the Iona Beach Cave, near a beautiful beach of pink shingle, and the Two Harbors Cave, in a park in the city of that name.

Along the Brule River, where it flows through Judge Magney State Park, in neighboring Cook County, is the famous Devil's Kettle. Supposedly, half the river vanishes as a waterfall into a 50-foot deep pothole eroded

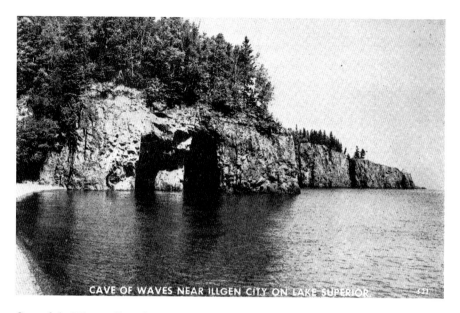

Cave of the Waves, a littoral cave excavated by wave erosion on the shores of Lake Superior at Crystal Bay, Tettegouche State Park. *Author's collection.*

into rhyolite bedrock. One guess was that there must be a secret lava tube more than a mile long that conveys this water to Lake Superior. While long dubbed a mystery, even by the prestigious Smithsonian website, the vanishing water is really only an optical illusion, as was proved by careful stream gauging by the DNR above and below the pothole in 2016. The water does not travel by a secret passage, but rather rejoins the Brule River in the immediate vicinity. Non-recovery of objects thrown into the pothole proves little, as they get caught up in eddies and woody debris under the waterline. The ironic thing is that stream gauging has also revealed that many North Shore rivers unexpectedly do decrease in volume as they flow downstream, a phenomenon known as Surber's Paradox, named for fisheries biologist Thaddeus Surber (1871–1949), who first described it in 1922. The water sinks into rock crevices, but where it remerges is uncertain. The hunt for the missing springs is still ongoing.

8
HEAVEN AND HELL

Caves were used for ritual purposes back in Paleolithic times and many religions used caves for religious purposes. In classical antiquity, the Greek god Zeus was born in a cave. Jewish burial caves exist in Palestine. Jesus Christ was born and buried in a cave. Christians worshipped in the Roman catacombs. The Mithraic cult constructed cave chapels. Buddhists and Hindus have sacred caves. Mohammed hid in a cave from his enemies. Caves have also played infernal roles. Minnesota caves include examples of both.

UNKTAHE'S CAVE

"Camp Coldwater," according to historians White and Lindberg, "was the first settlement of European-Americans in Minnesota that was not primarily a fur trading post, fort, or mission....The site...was the location of many 'firsts' in Minnesota history, a good reason to call it the birthplace of Minnesota." Indeed, Camp Coldwater, in Minneapolis, has been called Minnesota's Plymouth Rock. The spring that gave its name to the encampment gushes from the Platteville Limestone at sixty gallons per minute. As early as 1819, the spring supplied early Fort Snelling with cold drinking water—a welcome alternative to the warm, turbid waters of the nearby Mississippi River. A stone-walled reservoir was built in 1880,

impounding the waters. In later years, this reservoir served as a trout pond on what became the U.S. Bureau of Mines's property, now part of the Coldwater Spring Unit managed by the National Park Service. The trout devoured the amphipods that swarmed in the pool, one of their favorite foods. But the spring is also sacred to Native Americans, for a special reason.

Unktahe (there are many variant spellings of the word) was the Dakota god of water and the underworld. Historically, the Camp Coldwater spring was associated with Unktahe, who was often visualized as a fish or serpent. Mary Henderson Eastman wrote in 1849, "Unktehi, the god of the waters, is much reverenced by the Dahcotahs. Morgan's Bluff, near Fort Snelling, is called 'God's house' by the Dahcotahs; they say it is the residence of Unktehi, and under the hill is a subterranean passage, through which they say the water-god passes when he enters the St. Peter's [Minnesota River]. He is said to be as large as a white man's house."

Dorsey, in his "Study of Siouan Cults" for the U.S. Bureau of Ethnology, wrote about "The Unktehi, or Subaquatic and Subterranean Powers," in 1894:

> *The gods of this name, for there are many, are the most powerful of all. In their external form they are said to resemble the ox, only they are of immense proportions. They can extend their horns and tails so as to reach the skies. These are the organs of their power. According to one account the Unktehi inhabit all deep waters, and especially all great waterfalls. Two hundred and eleven years ago, when Hennepin and Du Luth saw the Falls of St. Anthony together, there were some buffalo robes hanging there as sacrifices to the Unktehi of the place....It is believed that one of these gods dwells under the Falls of St. Anthony, in a den of great dimensions, which is constructed of iron.*

More than a century later, Gary Cavender, a local Native American spiritual leader, filed an affidavit in the Highway 55 case, in which the rerouting of the nearby highway threatened Coldwater Spring. In 1998, he stated:

> *The Camp Coldwater spring is a sacred spring. Its flow should not be stopped or disturbed. If the flow is disturbed, it cannot be restored. Also, if its source is disturbed, that disturbs the whole cycle or the flow. The spring is the dwelling place of the undergods and is near the center of the Earth. The spring is part of the cycle of life. The underground stream from the*

spring to the Mississippi River must remain open to allow the gods to enter the river through the passageway. The spring is the site of our creation myth (or Garden of Eden) and the beginning of Indian existence on Earth. Our underwater god (Unektehs) lives in the spring. The sacredness of the spring is evident by the fact that it never freezes over, and it is always possible to see activity under the surface of the water.

Coldwater Spring gushes from a stone spring house at a corner of the reservoir. Upon closer examination of its conduits, geologists only recently discovered that it was a triple spring whose annual chemical cycles of salt and temperature reflected the city's metabolism. But the only suggestion of Unktahe's Cave is when the stone-walled pool becomes heavily overgrown with aquatic vegetation. Staring into the murky depths, it almost appears as if some creature is stirring down there, among the waving fronds.

NEWTON JENNY'S CAVE

According to the newspaper clippings, Newton Jenny was an early settler deluded by a prophetess into digging through a sandstone hill near Cannon Falls, Minnesota, in search of a pot of gold, to test his faith. The tunnel was dug from 1865 to 1870 but dead ends after thirty-five feet. Next, he decided to dig for a river of gold, excavating a well downward into the sandstone, with similar results.

With permission of the landowner, I visited Newton Jenny's Cave in 2006 and found it substantially as reported, but no gold was evident. Jenny lived back during a time when it was accepted practice to dig into Native American burial mounds in search of loot, and one possibility is that the analogy was mistakenly carried over from digging through soil making up such a mound, to digging the solid bedrock of St. Peter Sandstone.

DEVIL'S CAVE

Despite having such a diabolical name, getting to Devil's Cave requires a long trek uphill into the heavens. High up a ravine in the colorful sandstone bluffs above Winona, Minnesota, is a long, narrow, natural cave in a city

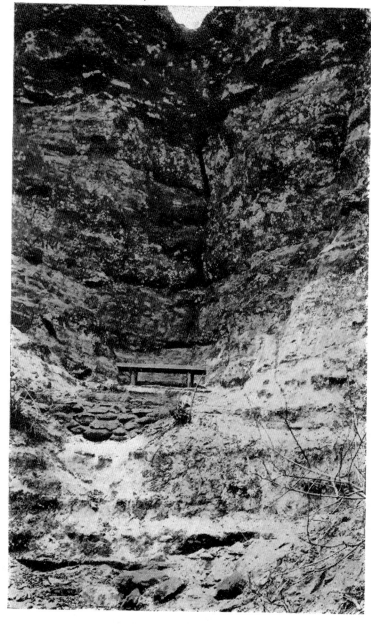

Devil's Cave, a narrow, vertical crevice high in the devil-red bluffs above Winona, Minnesota. *Author's collection.*

park, featured on early postcards. Developed along a joint in the Jordan Sandstone, eighty feet long, it requires gymnastic maneuvers to get to the so-called party room at the far back end of the cave. How the cave got its name is a mystery, but I once found an amulet back there, and from the accumulation of detritus I could see that it is a party cave for the locals, if that be devilish. For what it's worth, the densest cluster of devil-type names for karst features occurs in the vicinity of Chatfield, Minnesota.

Tunnel of Terror

Caves have been refuges, but they have also been places of terror, dating back to the Minotaur's labyrinth in ancient Crete. Many caves worldwide are decorated for Halloween, but the Tunnel of Terror, also known as the Marina Caves and the Univac Caves, were certainly the most elaborate Halloween caves ever seen in Minnesota, large enough to contain multistory "castles" and requiring rope-led tours.

The one and a half miles of passages in the St. Peter Sandstone making up this mine were dug below what is now Shepard Road at Davern Street. The passages are about twenty feet wide and thirty feet high—wide enough for two trucks to pass side by side and higher than a telephone pole. The Civil Defense map of the mines—usually called caves—dating from 1962 shows the "Holiday Harbor Sand Caves" with its dozen entrances in the bluffs behind the St. Paul Marina. These passages were rated to shelter 1,953 occupants.

From 1981 to 1989, Gary Svoboda rented the abandoned mine for boat storage as part of the Watergate Marina. According to him, the caves remained vacant for nearly a generation after silica mining ended in the 1940s, except for countless clandestine sorties from local teenagers—as testified by the abundant graffiti. Kids got into the cave, partied the nights away and carved elaborate pieces, like the "Stairway to Heaven" in a remote passage. Going up this slippery "stairway" to the giddy alcove and downing a six-pack must have been a real thrill for them.

Svoboda found that he could store as many as 450 boats, up to sixty feet in length, in the old sand mines, adding "a King Kong–sized steel door" for protection. The installation of mercury-vapor lights, blacktopping and guniting the walls to reduce erosion, cost $100,000. It was advertised as the "Upper Midwest's Largest Underground Storage Facility." But boat storage

didn't pan out, as mice and mold gnawed at the boats during the winter and chunks of ceiling occasionally came crashing down onto the boats from above. The boats also took on a peculiar, lingering earthy odor that was difficult to eradicate.

In 1982, the Jaycees (Junior Chamber of Commerce) offered their first Halloween house of horrors at this former sand mine, renting out space next to Svoboda. Early in the tour, you passed the whimsical scene of a skeleton driving a boat—perhaps a reference to the Svoboda boat storage. The creepiest part was just beyond, the Land of Shadows, where you walked between rows of black-robed figures on either side. Most of them were inanimate scarecrows, but it was the occasional ambush by a living figure that got the screams. The faux forest, festooned with cottony cobwebs, was put together from actual waste brush sprayed with fire retardant.

The first big set piece, Frankenstein's Castle, was twenty-five feet, or three stories, high. It was built of plywood, onto which had been glued Styrofoam stones to give the castle a rusticated appearance. The tower of the castle, illuminated with a red chandelier, served the volunteers as a vantage point from which to observe activities in passages running off in three directions. Entering the castle, you passed through Dr. Frankenstein's workshop, furnished with imitation electrical apparatus, such as cast-off computer monitors.

The Unholy Tomb and the Sanitarium was controlled from a computerized power tower, where the operator could observe the action. Spooky music—loud enough to suppress unwanted conversation—was forever blasting from the tower, including soundtracks from *Psycho, 2001: A Space Odyssey* and *Terminator 2*.

The entrance to this domain was a pyramid topped with a garish cyclopean eye, like the Masonic pyramid on a dollar bill. Once inside the set, you saw a grasshopper-green, two-armed, four-legged object of devil worship in a graveyard, with a rotating fireplace light behind the set creating the appearance of fire on the sandstone walls. Volunteers pretended to worship this devil, while a recording of a monk chants the seven names of the devil.

Visitors to the Sanitarium were saluted by a shrill siren blast and a burst of blinding light. Ushered into a courtyard, visitors were swept with searchlights, harassed by ghouls, and dive-bombed by an airborne lobotomy patient—actually a dummy on a rope. Visitors approached an elaborately crafted two-story façade, complete with gables, meticulously modeled on a real sanitarium at Danbury, Massachusetts, where lobotomies were the

History & Lore

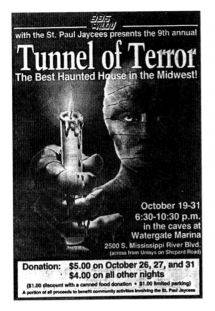

Advertisement for the Tunnel of Terror in the Marina Caves, 1990. *St. Paul Pioneer Press.*

operation of choice. This stagecraft was reportedly inspired by the campy movie *Session 9*, set at Danbury.

After leaving this fantasy landscape, with its billows of white fungus, you entered the Crematorium, a lengthy strobe tunnel that seemed to decrease in size ahead of you, literally narrowing your options. After that you followed the Path to Hidden Falls, referring to the well-known waterfall in Highland Park. A prominent sign bore the enigmatic words, "Have Gear Loaded and Friends Ready to Go," leaving you to ponder the original context.

The second great castle in the mine was Dracula's Castle. The door plate indicated the occupant—Vlad III Tepes—together with the year, 1456.

A fairly early cave date for the Twin Cities! Behind the scenes there was an industrial-strength fogging machine. While there was fog throughout the mine, this was the most heavily saturated area, with its own underground distribution pipes. After this, you had to stroll through Dracula's Red Room, with its heavy wooden beams and red chandeliers. Volunteers, their bodies painted with a brick pattern to match the walls, suddenly leapt out at the startled visitors.

In later years, the Tunnel of Terror drew twelve thousand visitors annually during its October weekend showings. I personally recall having seen lines of people a quarter of a mile long waiting to get into this very popular event. The caves having been dug by the Ford Motor Company to supply its production line, the Jaycees had likewise organized the Halloween industry, constructing a large-scale production line of fun and fright at the Tunnel of Terror. But after the deaths of three teenagers in the Fandell Caves in 2004 from carbon monoxide poisoning, the fire inspectors demanded another fire exit to the mine, which proved too expensive for the Jaycees. Thus ended a proud twenty-three-year tradition.

GENERAL REFERENCES

Alexander, E.C., Jr., ed. *An Introduction to Caves of Minnesota, Iowa, and Wisconsin*. Huntsville, AL: National Speleological Society, 1980.

Alexander, E.C., Jr., G. Brick and A. Palmer. "Minnesota." In *Caves and Karst of the USA*, edited by Arthur N. Palmer and Margaret V. Palmer, 146–50. Huntsville, AL: National Speleological Society, 2009.

Brick, G. *Fountain Cave: Saint Paul, Ramsey County, Minnesota*. Altoona, PA: Speece Productions, 2014.

———. "The Missing Century in the Minnesota Karst." *Minnesota Speleology Monthly* 37, no. 7 (July 2005): 75, 77, 78.

———. *Subterranean Twin Cities*. Minneapolis: University of Minnesota Press, 2009.

———. *Wakan-Tipi Cave (Carver's Cave): Saint Paul, Ramsey County, Minnesota*. Altoona, PA: Speece Productions, 2014.

Brueggemann, G.J. "Beer Capital of the State: St. Paul's Historic Family Breweries." *Ramsey County History* 16, no. 2 (1981): 3–15.

GENERAL REFERENCES

Culver, D.C., and W.B. White, eds. *Encyclopedia of Caves*. San Diego, CA: Elsevier Academic Press, 2005.

Ford, T.D., and C.H.D. Cullingford, eds. *The Science of Speleology*. London: Academic Press, 1976.

Green, D. *Minnesota Underground and the Best of the Black Hills*. Black Earth, WI: Trails Books, 2003.

Gunn, J., ed. *Encyclopedia of Caves and Karst Science*. New York: Fitzroy Dearborn, 2004.

Hogberg, R.K., and T.N. Bayer. *Guide to the Caves of Minnesota*. Minneapolis: Minnesota Geological Survey, 1967.

Hovey, H.C. *Celebrated American Caverns*. Cincinnati, OH: Robert Clarke Company, 1896.

Kehret, R. *Minnesota Caves of History and Legend*. Chatfield, MN: Superior Printing, 1967.

Minnesota Geological Survey. *Text Supplement to the Geologic Atlas, Fillmore County, Minnesota*. St. Paul: University of Minnesota, 1995.

Minnesota Speleology Monthly, newsletter of the cave club since 1965. See especially the "Spelean History Corner" column by Greg Brick, which ran for a decade (2002–2012).

Ojakangas, R.W., and C.L. Matsch. *Minnesota's Geology*. Minneapolis: University of Minnesota Press, 1982.

Palmer, A.N. *Cave Geology*. Dayton, OH: Cave Books, 2007.

Winchell, N.H. *Aborigines of Minnesota*. St. Paul: Minnesota Historical Society, 1911.

INDEX

A

Ackerman, John 111
amphipods 37, 97, 126
anthropogenic caves 14
archaeoastronomy 34
Archaic period 19
Argonaut Society 113

B

Bacon, George 28
Banholzer Cave 57–59
bats 59, 118, 121
 hibernaculum 59, 63, 66, 106, 118, 123
 white-nose syndrome 58
Bavaria 56, 59, 61
beavers 37
Becker Sand & Mushroom Company 66
Beltrami, Giacomo 46

Bert the Turtle 119
Big Snake and Little Snake Caves 80
Black Medusa 93
Black Sea 93
Blue Grotto. *See* Stillwater Caves
Boomsite Cave 142
Boxmeyer, Don 57
Bretz, J Harlen 109
breweries
 Banholzer Brewery 57
 Grain Belt Beer 63
 Hamm's Brewery 61
 Heinrich Brewery 63
 Landmark Brewery 62
 Minneapolis Brewery 63
 Noerenberg Brewery 63
 North Mississippi Brewery 57
 North Star Brewery 61
 Schmidt Brewery 59, 61
 Stahlmann's Cave Brewery 59
 Yoerg Brewery 56
brewery caves 55–64

INDEX

Bromley's Cave 63
Bruce Vento Nature Sanctuary 37
buffalo snake 32
Burnley map 35

C

Camp Coldwater 40, 125
Camp Lacupolis 23
carbon monoxide poisoning 79, 81, 131
Carcass Crawl 48
Carver, Jonathan 13, 31
Carver's Cave 13, 19, 31–38, 45, 46, 64
Cascade Parlor 41
Castle Royal 73, 74, 77–79
Catacombs of Yucatan 113–115
Cave Farm 113
cave ice 123
Cave of the Dark Waters 43
Cave of the Waves 123, 124
cave pearls 48
cave saloon 74
Caves of Faribault. *See* Treasure Cave
cave unit 15
Chalybeate Springs 87
Chamberlin (Chamberlain), Luther 86, 113
Channel Rock Cavern 95–97
Channel Street 65, 73
cheese ripening 71–74
Cherokee Park 66
Chute's Cave 13, 83–91, 99
Chute's Tunnel 86, 87, 90, 91
City of the Birds 56
Civil Defense 66, 90, 119, 129
Civil War 13, 31, 43, 59, 83, 91

Cold War 119
Coldwater Spring 126
Colwell, John H. 34
Combs, Willes Barnes 71
Condor Corporation 67
Cornice Cliffs 41
Coyne the Prophet 52
Crystal Cave. *See* Fountain Cave
Crystal Chapel 106
Curtis Caves. *See* Stillwater Caves
Cyclops Cave 71

D

Dayton's Bluff 35, 61
Dayton's Bluff Cave 37
Decorah Shale 66
Devil's Cave 127–129
Devil's Kettle 123
Door-to-Door Route 105
Dornberg, David 91
Dracula's Castle 131
Driftless Area 14
Dungeons & Dragons 63

E

Eastman Tunnel disaster 89, 95
Echo Cave 66
Ellet, Elizabeth 40
Enigma Pit 106
Erickson, Bruce 20

INDEX

F

fallout shelters 66, 90
Fandell Caves 74, 81, 131
Farmers & Mechanics Bank Cave. *See* Schieks Cave
Felsenkellers 74
flowstone 28, 48, 63, 90, 93, 97, 105, 106, 111
fly-and-worm ecosystem 95
Ford Motor Company 15, 45, 131
Fort Snelling 15, 38, 39, 40, 46, 91, 125, 126
Fountain Beer Cave 58
Fountain Cave 13, 15, 37–45, 46, 47, 58, 99
Fountain Creek 37, 39, 45
Frankenstein's Castle 130
Frankenstein's Cave. *See* Banholzer Cave
French and Indian War 29

G

Galena limestone 14, 105, 111
gangsters 77
geotourism 88, 103
ghost stories 40, 79
Giant Beaver Cave 20
glowworm caves 56
gold cave 98
Goodhue, James 33
Great Cave. *See* Carver's Cave
Grotto Street 42
gunpowder 29, 57
gypsum 63

H

Haber-Bosch process 31
Heinrich Cave 63–64
Hiawatha Caverns (Wabasha County) 117
Hiawatha Caverns (Winona County) 115–117
Hidden Falls 20, 131
Hill, Alfred 19
Holiday Harbor Sand Caves. *See* Tunnel of Terror
Horseshoe Cave. *See* Mystic Caverns
Horse Thief Cave 53
Hovey, Horace Carter 113
hybrid and imaginary caves 16, 22, 46, 58, 64, 97, 125

I

Ice Age 19, 20, 24, 94, 95, 113, 121
ice caves 121
Illingworth, William H. 43
Illstrup, Carl J. 92
International Caverns. *See* Spring Valley Caverns
Iona Beach Cave 123
Ivory Cliffs 65

J

James, Jesse 50, 117, 118
Jenks, Albert 23, 28
Jesse James Cave (Blue Mounds State Park) 50–51

Jesse James Cave (St. Peter). *See* Seven Caves
Jordan Sandstone 16
Joseph Wolf Brewery Cave. *See* Stillwater Caves
Joy Avenue 65
Junior Pioneer Association 42

K

karst 14, 105, 129
Kasota stone quarries 117
Kehret, Roger 91
King Kong 75, 76, 129
Knapp's Cave 25–27
Korneski Cave 23
Kraft Cheese Cave. *See* V Caves

L

La Brea tar pits 113
lager beer 55
lagering 60, 61
Lake City Cave 103
La Moille Cave 20–22
La Moille Rockshelter 21
Land O'Lakes Cave. *See* Castle Royal
Latcham's Cave. *See* Spring Valley Caverns
Le Duc, William Gates 48
Lee Mill Cave 16, 22–23
Lehmann, William 70, 77
Les Eyzies 28
Leslie Cave. *See* Knapp's Cave
Le Sueur, Pierre-Charles 29
Le Sueur's saltpeter caves 30

Lewis, Henry 41
Lewis, Theodore 19, 20, 24, 34
Lilydale 57, 66, 70, 80
Little Minnehaha Falls 93
littoral cave 23, 123
Long, Stephen H. 37, 39, 46
Loop Cave. *See* Schieks Cave
Lundberg Cave 23

M

Magelssen's Cave 101
Mallery, Garrick 34
Mammoth Cave of Kentucky 27, 41, 67, 92, 99
Manhole Cave. *See* Schieks Cave
Marina Caves. *See* Tunnel of Terror
Mazeppa Cave 25
Meyer, Charlie 117
Miles Cave 16, 47–50
Miles, Nelson Appleton 48
Minnehaha Ice Cave 83, 84
Minnesota Blue 71, 73
Minnesota Cave Preserve 113
Minnesota Caverns 105
Minnesota Department of Natural Resources 63, 66, 105, 121, 124
Minnesota Historical Society 34, 45
Minnesota Speleological Survey 93, 103
Minotaur's labyrinth 129
Mississippi River flood of 1965 78, 80
mother map of Minnesota 38
Mouchenott, Albert 77
Mushroom Century 70
mushroom gardening 67

INDEX

Mushroom King. *See* Lehmann, William
Mushroom Valley 65–70, 74, 79
Mystery Cave 13, 103–106, 109
Mystic Caverns 66, 74–77, 75, 79
Mystic Tavern 74, 76

N

National Park Service 126
National Speleological Society 92, 97
Neill, Edward D. 56
Nesmith Cave hoax 13, 84
Nesmith, Reuben 83
Nesmith's Cave 84
Neuton's Cave 100
New Cave. *See* Fountain Cave
Newson, Thomas 34, 45, 59
New Stone House. *See* Fountain Cave
Newton Jenny's Cave 127
Niagara Cave 13, 106–108
Niagara Cavers 109
Niagara Spring 109
Nicollet, Joseph N. 38
nightclubs 74, 77, 99
Northern States Power Company 90
North Minneapolis Tunnel 92, 94
Nottingham, U.K. 65

O

Old Mystery Cave 103
Omaha Railroad 44, 45
Oneota dolomite 15

Oothoudt, Jerry 28
Owen, David Dale 15, 40

P

Paleo-Indian period 19
Parrant, Pierre 39
Pasteur Institute 67
Pasteur, Louis 61
Peltier Caves 81
Petrified Indian Cave 27–28, 103
petroglyphs 19, 20, 21, 24, 46
Pettengill's resort 87
Petty, Joe 103
pictographs 19
piezoelectricity 56
Pillsbury A Mill 89
Pipestone Quarry 34
piping 15
planetarium caves 34
Plato Boulevard 65, 79, 80, 81
Platteville Limestone 20, 52, 90, 95, 98, 125
Powell, Louis 20
Prohibition 56, 74, 77, 119

Q

Quarry Hill Cave 52–53
Quincy Caves 102

R

Reno Cave 24
Reno face 24
Revolutionary War 31

Robinson's Ice Cave 121–123
Rochester State Hospital 52
rock people 25
rockshelters 19
Roman catacombs 92, 125
Root River 28, 103, 105
Roquefort caves 71
Rundbogenstil architecture 61

S

saber-toothed cat 113
saltpeter 29–31
Samuel's Cave 25
sandhogs 95
Schieks Cave 15, 91–95
Schmidt Artist Lofts 62
Schoolcraft, Henry Rowe 38, 39, 46
Science Museum of Minnesota 20, 22
Seven Caves 117–118
Seven Oaks Oval Park 97
Seven Springs 106
Seymour, E.S. 41
shamanism 25
show caves 23, 40, 89, 99–120
silica mines 65
Silicon Valley 66
Silver Cave. *See* Mystic Caverns
Smith rockshelter survey 23
Spirit Island 98
Spirit Island Cave 97–98
Spring Cave. *See* Fountain Cave
Spring Valley Caverns 103, 109–113
Stahlmann, Christopher 61
Stahlmann's Cellars 59–62
Stairway to Heaven 129

St. Anthony Falls 32, 83, 89, 91, 95, 98
St. Anthony Falls ice cave 83
St. Anthony Falls Water Power Company 90
state parks
 Banning State Park 121
 Blue Mounds State Park 50
 Forestville State Park 103
 Judge Magney State Park 123
 Tettegouche State Park 123
Stenerson, Tim 48
Stillwater Caves 119–120
St. Paul Brick Company 66
St. Peter Sandstone 14, 40, 52, 59, 63, 65, 83, 90, 91, 92, 94, 95, 127, 129
SubTropolis 67
Surber's Paradox 124
Surber, Thaddeus 124
Svoboda boat storage 129
Swedish Underground 27
Sweeny, Robert O. 34

T

Thirty-Fourth Street Cave. *See* Channel Rock Cavern
Thunder Caves 123
TKDA cave survey 66
Tower of St. Anthony 86, 90, 91
Towne, Oliver 65, 67, 74
tray system 70
Treasure Cave 74
Treaty of Traverse des Sioux 117
Trophonian Cave 46–47
Tunnel of Terror 129–131

Twin Cities Grotto 92
Two Harbors Cave 123
Tyson Spring Cave 112, 113

U

Unholy Tomb and Sanitarium 130
Univac Caves. *See* Tunnel of Terror
University Cave 73
Unktahe 126
Unktahe's Cave 125–127

V

V Caves 71
Villaume Box & Lumber Company 71

W

Wabasha Street Caves 79
Wakan Tipi 31, 46
War of 1812 29, 31
Water Street 65, 79, 80
white mushroom (*Agaricus bisporus*) 67
White Rocks 15
Wilford, Lloyd 23, 27
Winchell, Newton Horace 14, 19, 21, 45, 91, 103
Wisconsin Dells 43
Woodland period 19

Y

Yoerg's Cave 56–57

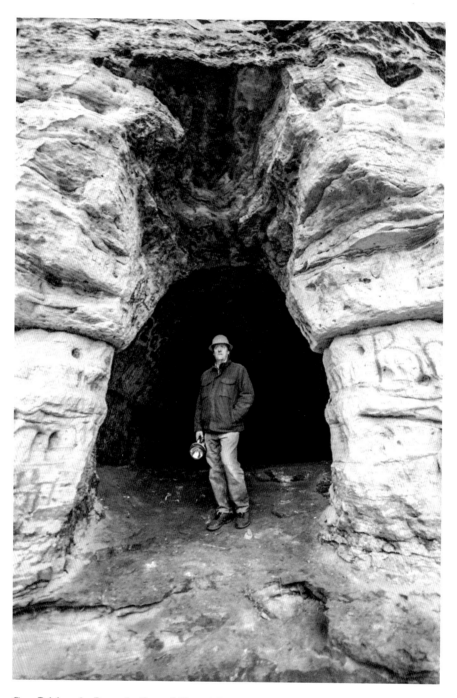

Greg Brick at the Boomsite Cave, Stillwater, Minnesota. *Tony Andrea, 2016.*

ABOUT THE AUTHOR

Greg Brick, PhD, was employed as a hydrogeologist at several environmental consulting firms and has taught geology at local colleges and universities. He has edited the *Journal of Spelean History* for the past dozen years. He has published more than one hundred articles about caves and was the recipient of the 2005 Cave History Award from the National Speleological Society. His first book, *Iowa Underground: A Guide to the State's Subterranean Treasures*, was published by Trails Media Group in 2004. His second book, *Subterranean Twin Cities*, was published by the University of Minnesota Press in 2009 and won an award from the American Institute of Architects. His work has been featured in *National Geographic Adventure* magazine as well as on the History Channel. He has led guided tours of caves for the Minnesota Historical Society and the University of Minnesota's College of Continuing Education.

Visit us at
www.historypress.net

This title is also available as an e-book